IMAGES
of America

PAGE AND
LAKE POWELL

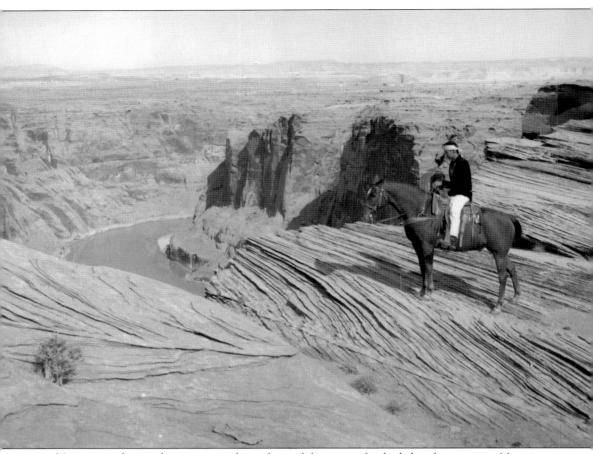

Upon a sandy, windswept mesa, sheep foraged for sparse food while a lone, young Navajo man watched from a shaggy horse. Manson Mesa had fed the sheep of Manson Yazzie's family for as long as one could remember, but that would soon end. A deal made in Washington, DC—half a world away—had traded away the mesa so that workers on the nearby Glen Canyon Dam project would have a place to live. Paul Jones, chairman of the Navajo Tribal Council, offered Yazzie's mesa in exchange for ancestral land on McCracken Mesa in Utah, which the tribe had wanted for a long time. Trade of this small tract of land (24.3 square miles) would forever change the entire landscape of the Navajo Reservation, as well as Northern Arizona and the West. Photographed on the rim of Glen Canyon on November 3, 1962, Merritt-Chapman & Scott Corporation high-scaler George Charlie is wearing traditional attire for a role in a US Bureau of Reclamation movie. (Photograph by A.E. Turner, US Bureau of Reclamation; courtesy of the Powell Museum Archives.)

ON THE COVER: The waters of Lake Powell began backing up behind Glen Canyon Dam in March 1963. It took almost 17 years for the lake to reach full capacity at 3,700 feet above sea level. Lake Powell has become the second largest man-made lake in the United States (behind Lake Mead). The reservoir was named for explorer John Wesley Powell and provides water storage, hydroelectric power, and a variety of recreational opportunities. The National Park Service manages Glen Canyon National Recreation Area, which encompasses Glen Canyon, Lake Powell, and extensive high-desert canyon lands in northern Arizona and southern Utah. (Photograph by the US Bureau of Reclamation; courtesy of the Howell R. Gnau Collection, Powell Museum Archives.)

IMAGES
of America

PAGE AND LAKE POWELL

Jane E. Ward, Kimberly Keisling,
and the Powell Museum Archives

ARCADIA
PUBLISHING

Copyright © 2014 by Jane E. Ward, Kimberly Keisling, and the Powell Museum Archives
ISBN 978-1-4671-3158-2

Published by Arcadia Publishing
Charleston, South Carolina

Printed in the United States of America

Library of Congress Control Number: 2013951306

For all general information, please contact Arcadia Publishing:
Telephone 843-853-2070
Fax 843-853-0044
E-mail sales@arcadiapublishing.com
For customer service and orders:
Toll-Free 1-888-313-2665

Visit us on the Internet at www.arcadiapublishing.com

For Steven F. Ward, who dedicated his life to
sharing his love for Page and Lake Powell.

CONTENTS

ACKNOWLEDGMENTS

The collection of photographs and history of the Page and Lake Powell area from early exploration through the 1980s would not be possible without the personal accounts of Page residents; documentation of people, places and events by forward-thinking individuals; and the dedicated staffs of local organizations working to preserve and keep the history of the area alive.

We would like to thank those involved in the Page Oral History Program overseen by the Powell Museum Archives, including the Page Public Library, Sara Beatty, Julia P. Betz, Karlyn Bunting, Linda Dieux, Richard Gilmore, Ada Hatch, Pam Jones, Stan Jones, Alley Keosheyan, Mary Melcher, Joan Nevills-Staveley, Bunny Nichols, Sharon Sichi, Cynthia Smith, Patricia Talbott, and Dorothy Warner. This invaluable historical resource includes more than 100 (and still growing) oral history interviews. Although each person remembers places and events slightly differently, the colorful stories and personal accounts bring life to the history of Page.

Most of the photographs included in the book were taken by the devoted staff of the US Bureau of Reclamation, including William A. Diamond, J.L. Digby, J.H. Enright, Fred S. Finch, H. Fink, Harry Gilleland, V. Jetley, Wilbur L. Rusho, A.E. Turner, and J.T. Vitaliano. A special thank you goes to the archival staffs of Glen Canyon National Recreation Area, the University of Utah Marriott Library, the Northern Arizona University Cline Library, and the *Lake Powell Chronicle* for providing access and permission to use important images from their collections.

We appreciate the support from individuals who donated collections, edited text, scanned images, combed the archives for important information, assisted in identifying photographs, and provided first-hand perspectives on the history of Page and Lake Powell, especially Julia P. Betz, Donna Bloxton-Petersen, Richard and Sharon Buck, Lillie Mae Gilleland, Brian Keisling, Mark Law, John Mayes, Dora Nelson, David and Debbie Sanderson, Cynthia Sequanna, Frank Talbott, Gay Ann Ward, Wanda Ward, Greg Woodard, and William Wright. We also extend a wholehearted "thanks" to the City of Page and all those who have worked tirelessly to make Page a wonderful place to live, work, and play.

INTRODUCTION

Prior to the early 1950s, what is now the city of Page, Arizona, was nothing more than a barren, sandy, desolate mesa in the isolated country of northern Arizona. Many people know the history of Page, including the construction of Glen Canyon Dam and Bridge, the filling of Lake Powell, and the transformation of the "trailer town" to the current, modern city it has become. As a well-known radio journalist frequently said, "And now the rest of the story."

Part of Page's story includes frequent references to the town as the last real frontier in the West—indeed, the early residents were truly pioneers in their own right. Once the US government decided to build Glen Canyon Dam, engineers, surveyors, and construction workers descended by the thousands to an area basically known only to local Indian tribes. Located in one of the most remote locations in the United States, there were no amenities in the area: no gas stations, no stores, no running water, no houses, and very few roads. In this country of beautiful mesas, buttes, canyons, and plenty of red sand, this hardy band of workers set out to build one of the most demanding projects in the history of the US Bureau of Reclamation: Glen Canyon Dam.

During the early construction years of the late 1950s, housing in Page was limited to only small mobile homes. People arriving to work on the dam were mostly strangers to one another, yet friendships developed quickly. As a new family came to town, others arrived to help them unload and move in. A lack of things to do only contributed to the closeness among residents who relied on one another and their own creativity for fun and entertainment. Children, especially, forged friendships that still endure today.

Life in developing Page was not always easy, and more of the "rest of the story" would have to include the blowing sand, which could literally cover the floor of a home. Scoop shovels rather than brooms were often used to clean houses following one of the frequent sand storms. Another unforgettable experience was crossing Glen Canyon on a swinging bridge with the Colorado River hundreds of feet down and the bridge swaying in the wind. The experience was not for the faint of heart, but early on it was the only way to get from one side of the canyon to the other.

Living in the isolation of Page only contributed to the growing spirit of helping others and volunteering for work that needed to be done in the developing town: building churches, a nine-hole golf course, a swimming pool, homes, parks, and playgrounds. Everyone pitched in, and helping others soon became a way of community life.

Another factor that contributed to the close friendships that developed was the element of danger that was always present on a project with the magnitude of Glen Canyon Dam. Lives were lost building the dam, but when disaster struck it was friends who provided the love and support needed by the families involved. Socioeconomic strata did not exist in Page—everyone was equal. If someone needed assistance it was always forthcoming.

During the formative years of Page, there was little tolerance for troublemakers, and the term "mobile home" could take on a totally new meaning at any time. It was not uncommon for a person causing problems on the job or in the community to come home only to find that their

trailer had been quietly moved outside the city limits and left there with a note wishing them the best of luck in their new location (wherever that may be)! Today, this would be referred to as a "zero tolerance policy."

The gates of Glen Canyon Dam were closed in 1963, and the beautiful water playground called Lake Powell began to fill. More than 6,000 people lived in Page at the time, and they witnessed a breathtaking transformation in the town and on the lake. Lands were now accessible by boat that had rarely been visited, except by a small handful of people. Visitors began flocking to this new recreational water wonderland, and along with them came the need for more services. New retail businesses, gas stations, restaurants, and homes developed, along with boat tours, river rafting trips, and local tours of nearby scenic spots. Approximately 17 years after closing the gates, Lake Powell filled for the first time. The area became the destination for some three million people annually.

Although too numerous to mention individually, the names of the Page pioneers who were instrumental in the development of the city will always be remembered. This book shall be a tribute to all of them and their families who helped make Page the outstanding city that it is today.

—by Richard Buck

Richard and Sharon Buck have contributed a significant amount of time and energy to the Page community through long and successful careers at Page High School and decades of involvement in local charities and organizations. Sharon Buck moved from Holbrook, Arizona, to Page, Arizona, with her family in 1957. Her parents, George and Eula Koury, ran Babbitt Brothers Trading Company, the first grocery store in Page.

One

THOSE WHO CAME BEFORE

The land that encompasses Page, Arizona, and Lake Powell is rich in cultural history. Beginning with the prehistoric Native American tribes who lived and hunted in the canyons and mesas surrounding Page, the area has a long history of explorers, inhabitants, and visitors.

Spanish explorers looking for a route from New Mexico to California across the massive gash in the landscape—cut by what they called the *Rio Colorado* (Red River)—crossed northern Arizona in November 1776. Maj. John Wesley Powell led another important survey of the area. The Powell expeditions were organized to explore and map areas in Wyoming, Utah, and Arizona along the Green and Colorado Rivers. They studied the geology, natural history, and native cultures of the area. The first Powell expedition embarked on its voyage on May 24, 1869, from Green River, Wyoming. Expedition members passed through Glen Canyon on August 3–4, 1869, and emerged from the Grand Canyon on August 30, 1869, with two boats and six men. The arduous expedition proved to be one of the most important exploratory trips of the Green and Colorado Rivers.

After Powell's surveys, growing interest in the region attracted prospectors, adventurers, and scientists. In the late 1800s, prospectors began to stake mining claims along the Colorado and San Juan Rivers in hopes of finding gold and silver. No substantial amount of gold was ever found in Glen Canyon, and many miners went bankrupt or pursued other interests. Archaeologists began exploring the area, and in 1909, two separate exploration parties—one headed by Byron Cummings and another by William B. Douglass—saw Rainbow Bridge for the first time. As plans to build Glen Canyon Dam solidified, survey crews worked feverishly to prevent cultural and scientific losses caused by the encroaching waters of Lake Powell. Lasting eight field seasons through 1963, the survey of the Glen Canyon area was conducted by the Museum of Northern Arizona and the University of Utah through contracts awarded by the National Park Service.

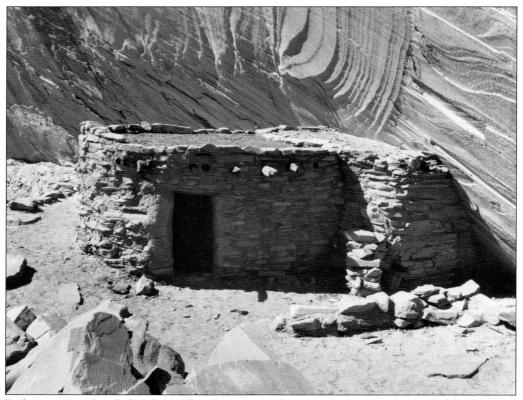

Prehistoric people inhabited the Glen Canyon area between approximately 11,550 BC and 1,300 AD. Glen Canyon is thought to have been a suitable region for hunter-gatherers and small-scale agriculture. This September 24, 1970, photograph shows Defiance House Ruin, which is located in Forgotten Canyon and was occupied from 1250 to 1285 AD. (Photograph by Harry Gilleland, US Bureau of Reclamation; courtesy of the Powell Museum Archives.)

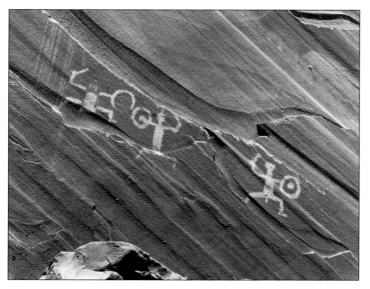

Though the rising waters of Lake Powell covered hundreds of miles of canyons, ecosystems, and archaeological sites, much evidence of prehistoric cultures still remains visible. Shown in this September 24, 1970, photograph, the pictographs at Defiance House Ruin are an excellent example of such evidence. (Photograph by Harry Gilleland, US Bureau of Reclamation, Howell R. Gnau Collection; courtesy of the Powell Museum Archives.)

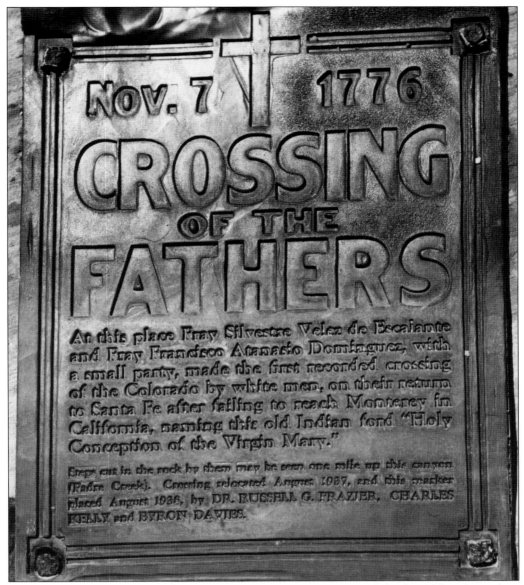

As early as the 1530s, Spanish explorers were surveying the American Southwest, but the earliest evidence confirming that these explorers were in the area surrounding Page was not until 1776. Francisco Atanasio Dominguez, appointed by the Spanish crown, led a group of men to chart a route from Santa Fe, New Mexico, to Monterey, California. After months of difficult travel, including food and clothing shortages and inclement weather conditions, the Dominquez-Escalanté Expedition was forced to return to Santa Fe without completing their mission. Their route took them along the banks of the Paria and Colorado Rivers near Lees Ferry, where they were unable to cross and were forced to climb out of the canyons at Dominguez Pass. They made their way to Wahweap Creek (near where Lake Powell Resort and Wahweap Marina are located today). The route led the Spanish explorers through an area north of Page (now known as the Crossing of the Fathers) near Gunsight Butte. (Photograph by A.E. Turner, US Bureau of Reclamation, Howell R. Gnau Collection; courtesy of the Powell Museum Archives.)

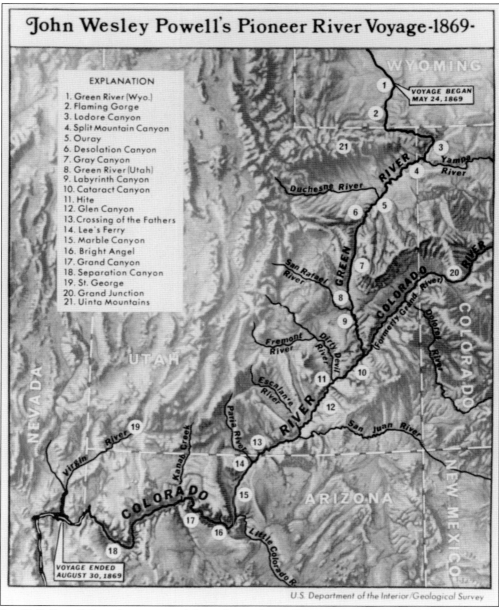

John Wesley Powell's Pioneer River Voyage -1869-

EXPLANATION

1. Green River (Wyo.)
2. Flaming Gorge
3. Lodore Canyon
4. Split Mountain Canyon
5. Ouray
6. Desolation Canyon
7. Gray Canyon
8. Green River (Utah)
9. Labyrinth Canyon
10. Cataract Canyon
11. Hite
12. Glen Canyon
13. Crossing of the Fathers
14. Lee's Ferry
15. Marble Canyon
16. Bright Angel
17. Grand Canyon
18. Separation Canyon
19. St. George
20. Grand Junction
21. Uinta Mountains

VOYAGE BEGAN MAY 24, 1869

VOYAGE ENDED AUGUST 30, 1869

U.S. Department of the Interior/Geological Survey

The 1869 Powell Expedition started from Green River, Wyoming, on May 24, 1869. The party passed through Glen Canyon in August 1869, naming the canyon after the glens they observed growing alongside the river. In his diary, John Wesley Powell noted, "So we have a curious ensemble of wonderful features—carved walls, royal arches, glens, alcove gulches, mounds, and monuments. From which of these features shall we select a name? We decide to call it Glen Canyon." Major Powell went on to study the canyons, people, geology, and water issues of the west in subsequent years. In 1871–1872, Powell made base camp in Kanab, Utah, where he conducted a land survey of southern Utah, the Arizona Strip, and parts of Glen Canyon. In his later expeditions, Powell was assisted by Mormon colonizers, such as Jacob Hamblin, Brigham Young, and John D. Lee. (Map by the US Geological Survey; courtesy of the Powell Museum Archives.)

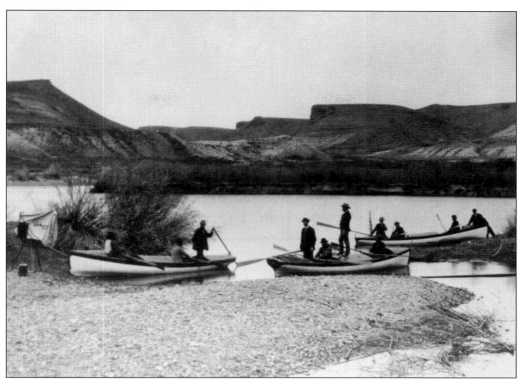

In this 1871 photograph, Maj. John Wesley Powell and his crew prepare to depart on their second exploratory journey. Seen here beginning their journey at Green River, Wyoming, are, from left to right, Andrew Hattan, Walter Clement Powell, Elias O. Beaman, Stephen Vandiver Jones, John K. Hillers, John Wesley Powell, Frederick S. Dellenbaugh, Almon Harris Thompson, John F. Steward, Francis Marion Bishop, and Frank Richardson. (Photograph by Elias O. Beaman; courtesy of the Dr. William Bishop Collection, Powell Museum Archives.)

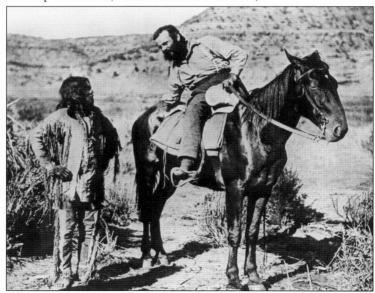

Maj. John Wesley Powell worked closely with Native American tribes in the southwest, developing friendly relations with Ute and Paiute tribal members in the 1870s. He compiled a dictionary of Ute vocabulary, learned to speak the language, and traded for cultural artifacts. (Photograph by John K. Hillers; courtesy of the Powell Museum Archives.)

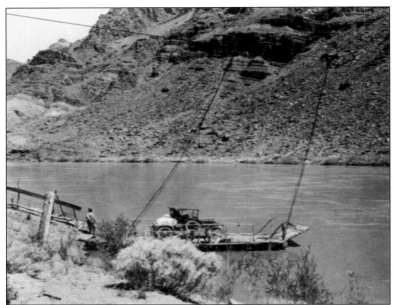

Shown here in 1917, Lees Ferry was an extremely important location for crossing the Colorado River for many explorers, settlers, prospectors, and local residents. It allowed early access to northern Arizona and southern Utah regions. (Photograph by W.H. Hopkins and Dolph Andrus; courtesy of the Glen Canyon National Recreation Area Archives.)

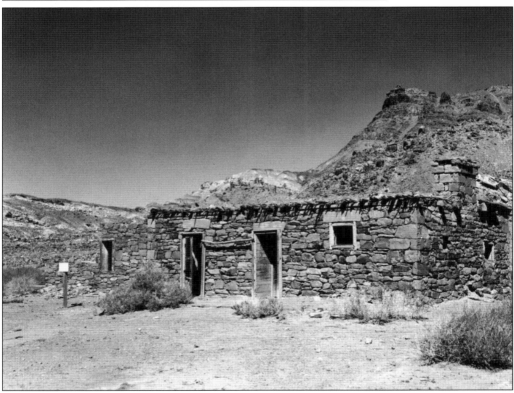

Mormon pioneer and Lees Ferry operator John D. Lee settled at Lonely Dell in 1871. Later, Charles H. Spencer used Lees Ferry Fort and built additional buildings from which he headquartered his mining operations. Lees Ferry Fort is pictured here on March 19, 1963. (Photograph by Wilbur L. Rusho, US Bureau of Reclamation; courtesy of the Powell Museum Archives.)

In 1879, Mormon settlers began their journey from several southern Utah communities to Bluff, Utah. The dedicated group traveled through rough, inhospitable country and endured severe weather to further expand their western colonies. Along their journey, the group—which consisted of more than 230 men, women, and children; 80 wagons; and hundreds of cattle and horses—blazed a trail across canyons, mesas, slick rock, and the Colorado River. They formed a base camp at Fifty Mile Spring roughly six miles from the Hole-in-the-Rock (a very narrow crevice in the west wall of Glen Canyon near the Colorado River). The pioneer road builders spent several months at Hole-in-the-Rock, blasting a road, building anchor points, and widening the passage for wagons. On January 26, 1880, the expedition began its descent to the river. There, they crossed Glen Canyon just south of the Escalanté River. Despite the dangerous nature of the route, the entire party made the descent. (Photograph by Stan Jones; courtesy of the Powell Museum Archives.)

Interest in mining Glen Canyon was spurred by rumors of a lost silver mine and the discovery of gold. In the early 1900s, Brothers Otto and Hector Zahn of the Zahn Mining Company ran a placer mining operation on the San Juan River and built a road into what is now known as Zahn Bay at Lake Powell. (Photograph by C. Gregory Crampton; courtesy of the Special Collections Department, J. Willard Marriott Library, University of Utah.)

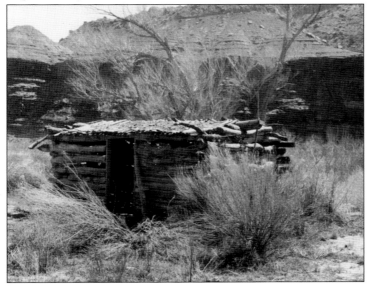

In 1883, Cass Hite found gold near Dandy Crossing on the Colorado River and set off the Glen Canyon gold rush. He built the first structure at Hite out of logs salvaged from the river and ran a small store and post office beginning in 1889. (Photograph by C. Gregory Crampton; courtesy of the Special Collections Department, J. Willard Marriott Library, University of Utah.)

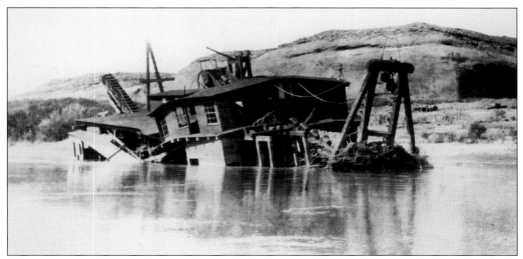

Mining engineer Robert Brewster Stanton's Hoskaninni Mining Company dredge, along with other abandoned equipment, now lie under the waters of Lake Powell near Bullfrog Marina. The mining operation was unsuccessful at extracting enough gold to make the endeavor profitable. (Photograph by Julius Stone; courtesy of the Grand Canyon National Park Archives.)

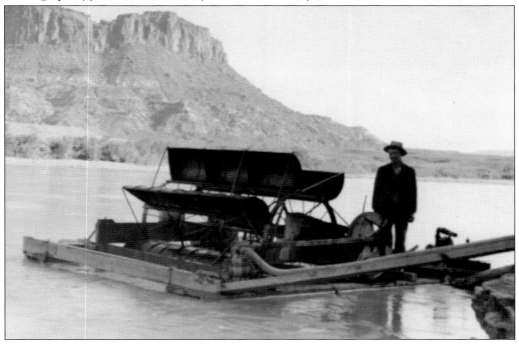

Pictured here on October 26, 1936, Mr. Gearhart operated a placer mine, along with other miners, on the east side of the Colorado River near Hite, Utah. Beginning in 1946, Arthur L. Chaffin ran a ferry service between the mining settlement (later named White Canyon) and Hite. The town of White Canyon was established in 1949 for workers at the uranium processing mill located at the mouth of White Canyon Wash. The mill closed in 1953, and the waters of Lake Powell covered the town in 1964. (Photograph by George Grant, US Department of the Interior; courtesy of the Glen Canyon National Recreation Area Archives.)

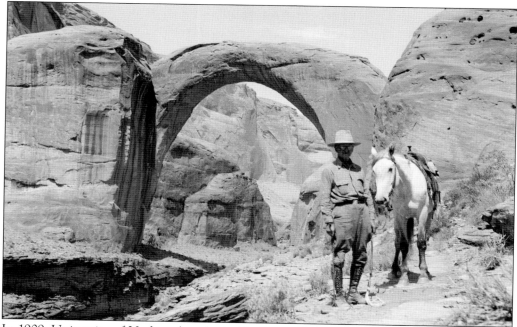

In 1909, University of Utah archaeologist Dr. Byron Cummings (shown here), general land office examiner of surveys William B. Douglass, and Paiute guides Jim Mike and Nasja Begay led discovery parties to the base of Rainbow Bridge. Local Native American tribes knew of the geologic feature well before 1909. (Photograph by Tad Nichols; courtesy of the Northern Arizona University Cline Library Special Collections.)

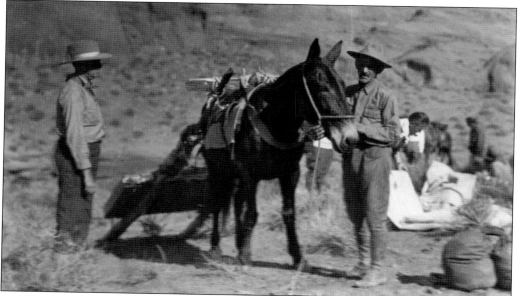

In 1927, an expedition was organized to install a commemorative bronze plaque honoring Nasja Begay, one of the 1909 Rainbow Bridge Expedition guides. John Wetherill, also a member of the 1909 trip, is pictured alongside a mule carrying the plaque. (Photograph by Raymond Armsby, courtesy of the Glen Canyon National Recreation Area Archives.)

In anticipation of the rising waters of Lake Powell, multidisciplinary research was conducted in Glen Canyon by the University of Utah. In this September 1957 photograph, head of botany Dr. Walter P. Cottam and professor of botany Dr. Seville Flowers place plant specimens between pressboard for laboratory studies. (Photograph by Stan Rasmussen, US Bureau of Reclamation; courtesy of the Glen Canyon National Recreation Area Archives.)

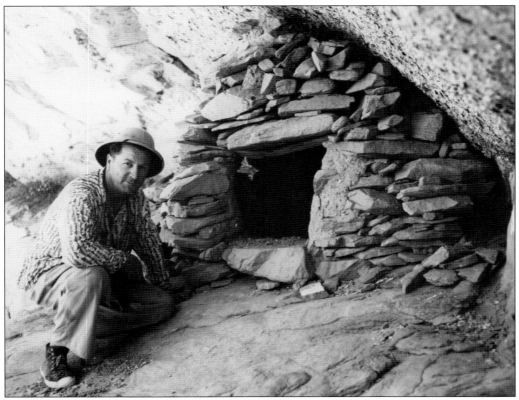

University of Utah archaeologist Jesse D. Jennings led archaeological research teams in Glen Canyon from 1956 to 1963. Reed Jensen is pictured in September 1957 exploring an archaeological site located on a shelf along a cliff in Glen Canyon. (Photograph by Stan Rasmussen, US Bureau of Reclamation; courtesy of the Glen Canyon National Recreation Area Archives.)

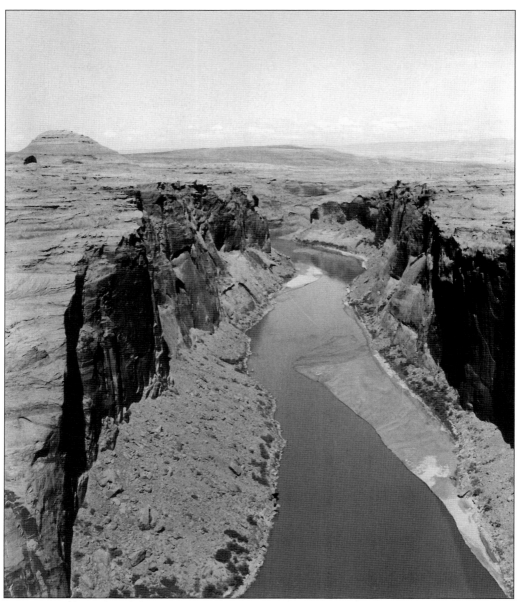

Assessments from the Glen Canyon salvage project included over 30 volumes of University of Utah Anthropological Papers covering a variety of topics and a series of publications by the Museum of Northern Arizona. Most of the 2,000 archaeological sites that were recorded were not inundated by Lake Powell. University of Utah head archaeologist Jesse D. Jennings referred to the prehistoric people who inhabited the Glen Canyon region as ingenious at retrieving and utilizing limited water resources for farming and daily use. Pictured here on October 3, 1956, the Colorado River was named by Spanish explorers in reference to the reddish-brown sediment that was suspended in the river water. Prior to Glen Canyon Dam construction, natural flooding from rainstorms and melting snow from the Rocky Mountains would scour and reshape the canyon each year. (Photograph by the US Bureau of Reclamation; courtesy of the Powell Museum Archives.)

The Museum of Northern Arizona was awarded contracts to conduct archaeological surveys in the Glen Canyon area beginning in 1956. The surveys were known as the Glen Canyon Project and often focused on archaeological sites that would likely be inundated by the rising waters of Lake Powell. This survey crew is pictured leaving West Canyon in 1960. (Photograph by Tad Nichols; courtesy of the Northern Arizona University Cline Library Special Collections.)

Prior to the construction of Glen Canyon Dam, Dr. C. Gregory Crampton, professor of history at the University of Utah, led surveys of the Glen Canyon area and mapped, photographed, and cataloged hundreds of historical sites. His crew is pictured on the beach near Music Temple Canyon, which was named by the Powell Expedition. (Photograph by C. Gregory Crampton; courtesy of the Special Collections Department, J. Willard Marriott Library, University of Utah.)

Land near the Glen Canyon Dam site was historically home to Navajo sheepherders and their families, who lived in traditional hogans. Early residents remember large herds of antelope freely roaming and grazing in the area. (Photograph by J.H. Enright, US Bureau of Reclamation; courtesy of the Powell Museum Archives.)

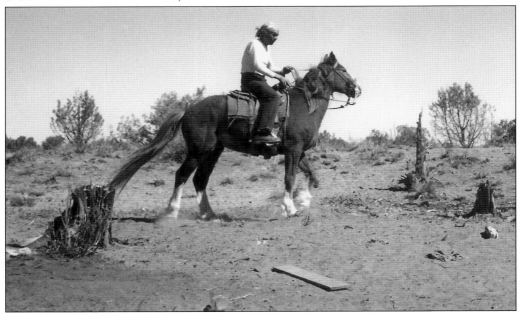

In this April 14, 1958, photograph, Navajo herder Cecil Begay rides off to tend sheep on the reservation near the Glen Canyon Dam construction site. Approximately eight families seasonally grazed sheep in the vicinity of the Glen Canyon Dam prior to the land exchange and construction of the dam. (Photograph by A.E. Turner, US Bureau of Reclamation; courtesy of the Powell Museum Archives.)

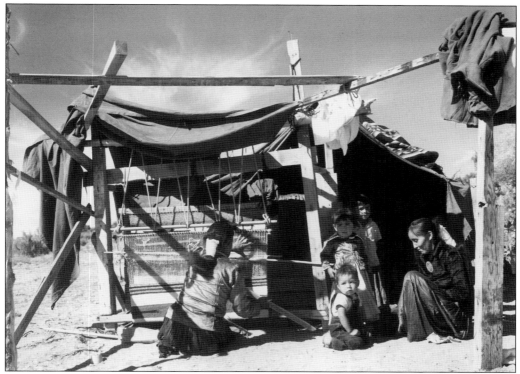

Alma Touchin Tacheenie weaves a woolen rug at her home near Coppermine, Arizona, on September 27, 1961. Many weavers traded their textiles to local trading posts, such as Gap and Coppermine Trading Posts, in return for food and supplies. (Photograph by A.E. Turner, US Bureau of Reclamation; courtesy of the Powell Museum Archives.)

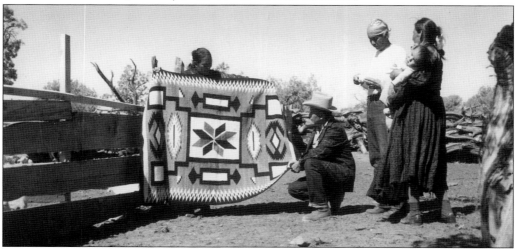

Mrs. John Lane displays a hand-woven rug to Abe Begay, Cecil Begay, and Mrs. Cecil Begay near Coppermine, Arizona, on April 14, 1958. Traditional Navajo weavers created functional wool blankets that served many purposes, such as clothing, cloaks, bedding, saddle blankets, furnishings, and trade goods. (Photograph by A.E. Turner, US Bureau of Reclamation; courtesy of the Powell Museum Archives.)

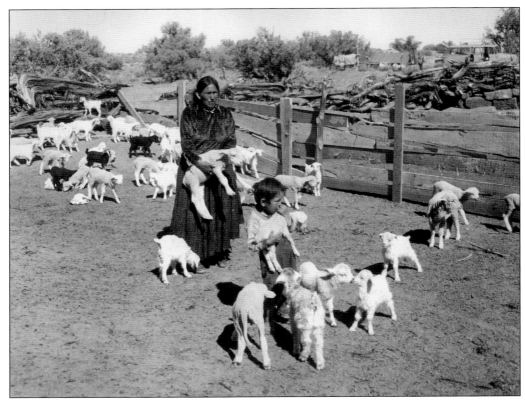

In the 17th century, the Navajo people acquired flocks of Churro sheep from Spanish settlers and became skilled herders and weavers, relying heavily on sheep for food and wool. Mrs. Cecil Begay and a boy are pictured here on April 14, 1958, carrying lambs in the corral after separating them from the herd. (Photograph by A.E. Turner, US Bureau of Reclamation; courtesy of the Powell Museum Archives.)

The Navajo people struggled to reestablish their herds of sheep after the stock reduction programs of the 1930s. Shown here on April 14, 1958, Cecil Begay spreads oats and corn among his herd of sheep and goats in the morning sun before they are driven out on the range. (Photograph by A.E. Turner, US Bureau of Reclamation; courtesy of the Powell Museum Archives.)

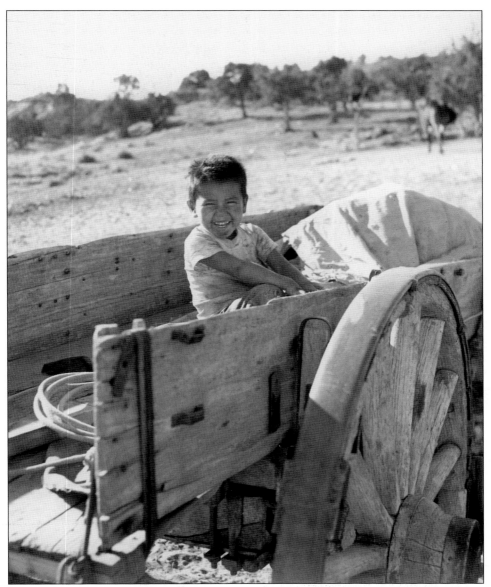

Few roads and extensive canyon systems made transportation difficult in northern Arizona prior to the completion of access highways. Many Navajo families traveled long distances by foot or horse and wagon over drifting sand, mesas, and canyons to trade for basic supplies. Early trading posts and stores included the Coppermine Trading Post, Bitter Springs Trading Post, Gap Trading Post, Cedar Ridge Trading Post, Inscription House Trading Post, Navajo Mountain Trading Post, Marble Canyon Lodge, and a store at Lees Ferry. They were established in the region to serve Mormon settlers, miners, and the Navajo people. After paving roads and the establishment of the town of Page, trading posts sprung up in Page, including Glen Canyon Trading Post, Pow Wow Trading Post, Blair's Dinnebito Trading Post, and Big Lake Trading Post (along with many other stores, restaurants, and services). Four-year-old Byron Tsiniginie is pictured on October 15, 1958, playing in an old buckboard wagon near Coppermine, Arizona. (Photograph by J.L. Digby, US Bureau of Reclamation; courtesy of the Powell Museum Archives.)

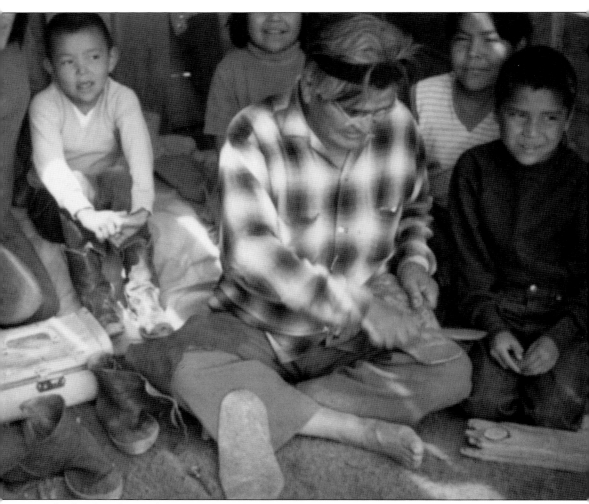

The land exchange between the federal government and the Navajo Nation was enacted on September 2, 1958. The trade transferred all right, title, and interest to the land, which became Page, Arizona, for lands northwest of Aneth, Utah. Families living in the areas where the Glen Canyon Dam project would be affected were relocated to other reservation lands—in many cases without prior consultation. In 1958, Manson Yazzie (for whom Manson Mesa was named) and his family, along with other families, had grazing rights to the land where Page, Arizona, is now located. Some Navajo men went to work on the Glen Canyon Dam construction project. Many Navajo children went to school in Page and later went on to work in town in various capacities. Manson Yazzie's daughter Carol Manson, for example, became a nurse at Page Hospital. Shown here, Manson Yazzie is making a pair of moccasins while surrounded by family members. (Courtesy of the Garnet and Uma Ridenhour Collection, Powell Museum Archives.)

Glen Canyon Dam project engineer Lem Wylie (second from left) and other US Bureau of Reclamation representatives talk with local Navajos about the construction of Glen Canyon Dam. Many Navajo families were displaced when the Manson Mesa and McCracken Mesa Land exchange took place. (Photograph by the US Bureau of Reclamation; courtesy of the Powell Museum Archives.)

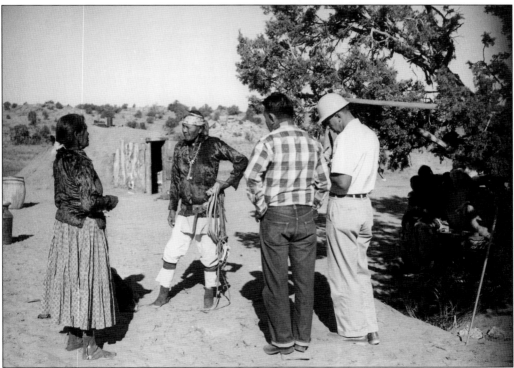

In this photograph from October 15, 1958, Leola and Alvin Tsiniginie of Coppermine, Arizona, are interviewed by US Bureau of Reclamation representatives Abe Begay and Wilbur L. Rusho. The Coppermine Trading Post, which was purchased by Coit and June Patterson in 1955, was established to serve miners and local Navajo residents and later served Glen Canyon Dam construction workers. (Photograph by J.L. Digby, US Bureau of Reclamation; courtesy of the Powell Museum Archives.)

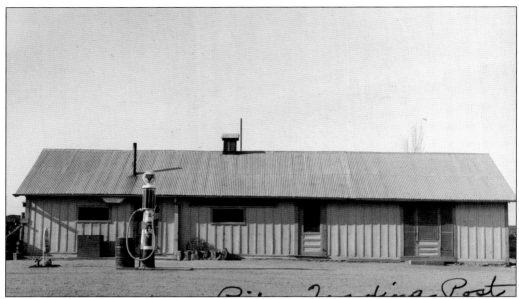

Shown here in 1936, Cedar Ridge Trading Post was also known as the Echo Cliffs Trading Post. Owned by the Babbitt Brothers Trading Company, it was originally located in Hamblin Wash near the Echo Cliffs. The store was moved when Highway 89 was paved in the 1930s. (Courtesy of the Northern Arizona University Cline Library Special Collections.)

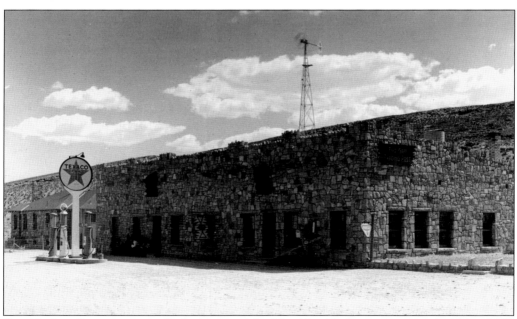

Gap Trading Post was originally built east of the Hamblin Trail near a gap in the Echo Cliffs where the road climbs onto the Kaibito Plateau to connect with Coppermine, Arizona. Beginning in the 1880s, the trading post was run by one of John D. Lee's sons to serve Mormon settlers. (Courtesy of the Arizona Historical Society and the Northern Arizona University Cline Library Special Collections.)

Two

GLEN CANYON DAM

After World War I, the growth of southern California cities accelerated the need for municipal water and electric power. Beginning in 1921, the US Geological Survey, Southern California Edison Company, and Utah Power & Light engineers launched topographical surveys, retracing much of Major Powell's original route for the purpose of selecting possible dam sites on the Green and Colorado Rivers. The 1922 Colorado River Compact, an agreement governing the allocation of water rights, was signed on November 24, 1922. The Compact and the Colorado River Storage Project Act (passed by Congress in 1956) led to the eventual construction of the Glen Canyon Dam and other dams in the Upper Colorado River Basin but not without resistance. Sierra Club president David Brower bargained with the US Bureau of Reclamation to prevent a dam from being built that would have flooded Dinosaur National Monument, compromising instead for a dam at Glen Canyon—this decision haunted Brower the rest of his life.

The first Glen Canyon Dam workers lived in Glen Canyon City (now Big Water), Kanab, Utah, or on the west side of Glen Canyon near an odd sandstone mound known as the Beehive. The Bureau of Reclamation and its prime contractor, Merritt-Chapman & Scott Corporation, built offices and temporary barracks to house the workers. The only way across the river at that point was a narrow walking bridge, described by some of the earliest residents as the "chicken wire bridge," which swung hundreds of feet above the river and the construction site far below.

Roads from Flagstaff, Arizona, and Kanab, Utah, were developed and eventually connected by the completion of Glen Canyon Bridge. Roads were paved for the trucks carrying the materials needed for the massive project, and these roads changed the landscape of the reservation forever. Opportunities for access and business were presented to those living along highways, thus giving new life to small settlements and trading posts like Gap, Bittersprings, Coppermine, and Cedar Ridge. The quiet, secluded life of many Navajo people transformed into 20th-century commerce, education, and industry.

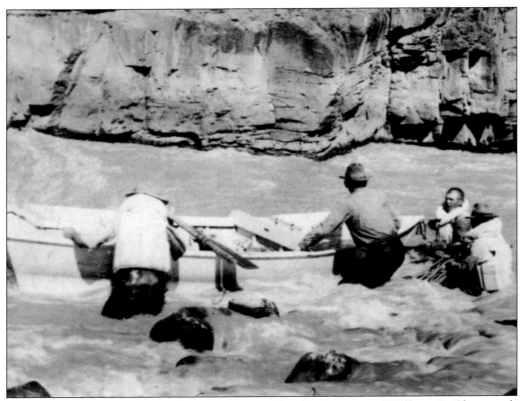

One of the 1921 US Geological Survey crews under the direction of William R. Chenoweth surveyed the Colorado River between the Dirty Devil River and Halls Creek. Then, in July 1921, they started their trip along the Green and Colorado Rivers from Green River, Utah. The crew is pictured on August 8, 1921, nosing their boat (the Colorado) through Lower Disaster Falls. (Photograph by US Geological Survey; courtesy of the David S. Clogston Collection, Powell Museum Archives.)

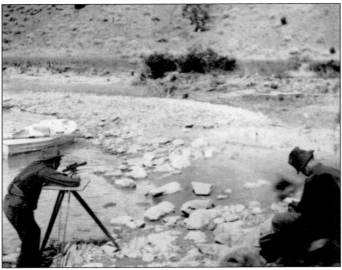

Each of the three 1921 topographical survey parties included a topographic engineer, a recorder, rodmen, boatmen, a cook, and a geologist. Just above Gold Point in Red Canyon, Trimble and Wooley, members of the Chenoweth 1921 US Geological Survey crew, set up survey equipment on July 24, 1921. (Photograph US Geological Survey; courtesy of the David S. Clogston Collection, Powell Museum Archives.)

First mapped and named by the 1869 Powell Expedition, Echo Park is located along the Green River. The proposed Echo Park Dam site is shown from a point above the mouth of Pool Creek in Dinosaur National Monument in this August 7, 1921, photograph. (Photograph by US Geological Survey; courtesy of the David S. Clogston Collection, Powell Museum Archives.)

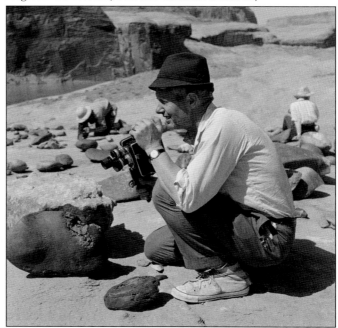

David Brower served as director of the Sierra Club from 1952 to 1969. He, along with other environmental groups, opposed building a dam at Echo Park because of the flood waters that would engulf Dinosaur National Park. Brower compromised for a dam to be built at Glen Canyon instead. He is pictured on a Sierra Club trip through Glen Canyon in 1963. (Courtesy of the Northern Arizona University Cline Library Special Collections.)

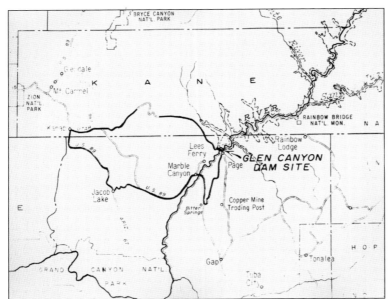

Access roads to the Glen Canyon Dam site had to be built prior to dam construction. This map shows the newly completed Highway 89 from Bitter Springs to Page, Arizona, and an almost completed highway to Kanab, Utah. (Photograph by the US Bureau of Reclamation; courtesy of the Powell Museum Archives.)

Seen here on December 3, 1956, the Bitter Springs access highway was the main road to the Glen Canyon Dam site on the east side of Glen Canyon. Prior to highway development, access to the area was by two-track dirt road. (Photograph by Fred S. Finch, US Bureau of Reclamation; courtesy of the Powell Museum Archives.)

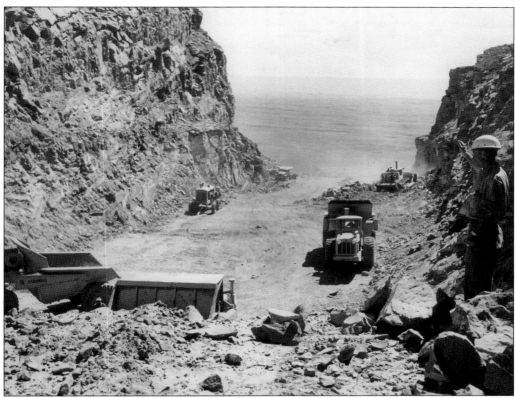

Construction of the "big cut" south of Page allowed Highway 89 to be rerouted to the Glen Canyon dam site, thereby opening a direct route for equipment and supplies. The first load of cement for the Glen Canyon Dam construction site left Clarkdale, Arizona, in October 1959 and was transported by Belyea Trucking Company. This January 3, 1957, photograph shows the construction route. (Photograph by F.S. Slote, US Bureau of Reclamation; courtesy of the Powell Museum Archives.)

Steady streams of aggregate hauling rigs left the loading tunnel from the aggregate plant to the Glen Canyon Dam site. Pictured here in October 10, 1961, these rigs used a Mack tractor and two trailers with sideboards and oversized tires for a total capacity of 75 tons. (Photograph by Wilbur L. Rusho, US Bureau of Reclamation; courtesy of the Powell Museum Archives.)

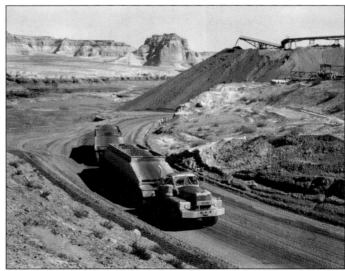

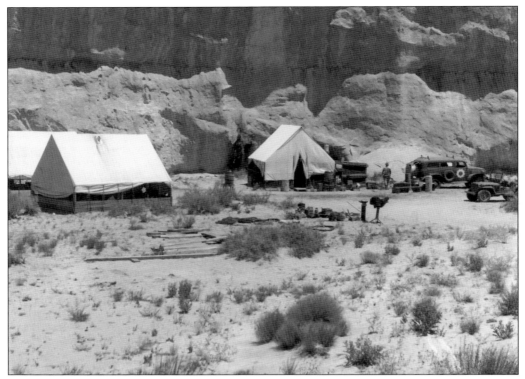

Initially, Kanab, Utah (75 miles west of the dam construction site), was the headquarters for dam personnel. Temporary tent buildings and camp for the survey crew of the Glen Canyon Dam site were also located on the west side of Glen Canyon in 1955. (Photograph by the US Bureau of Reclamation; courtesy of the Powell Museum Archives.)

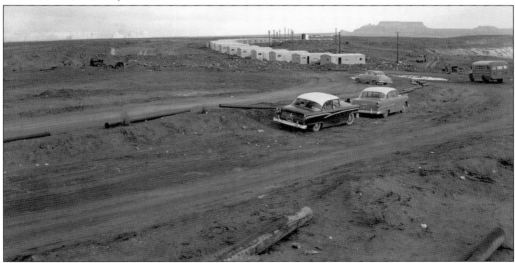

Transported into Page over long distances on rough roads, Transa-homes were used as housing by US Bureau of Reclamation employees and their families. Seen here on November 5, 1957, the pink-colored homes lined South Navajo Drive near the temporary school buildings. (Photograph by Fred S. Finch, US Bureau of Reclamation; courtesy of the Powell Museum Archives.)

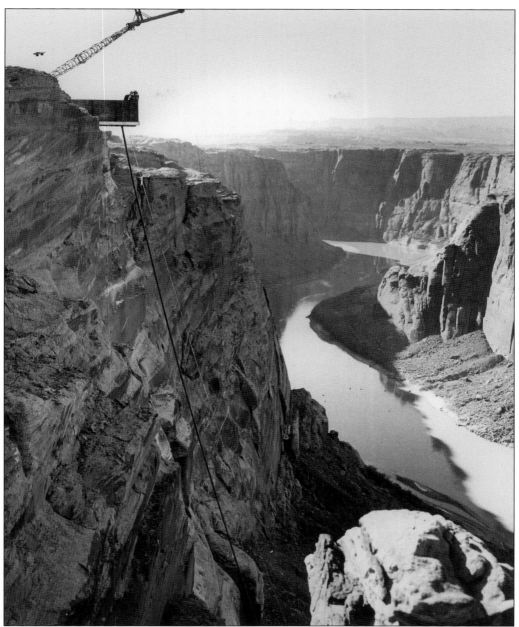

Seen here on December 19, 1956, the W.W. Clyde Construction Company installed a water pipe on the east wall of Glen Canyon to help the Bitter Springs road work. Water for the town was also pumped from the Colorado River at a pumping station a few miles below the dam construction site. An attendant had to monitor the station day and night to keep it in working order. A basin with strainers and a large intake hose was placed in the river. An exposed pipe (approximately eight inches in diameter) brought water more than 700 feet up the steep canyon walls to water storage tanks on Manson Mesa, where it was purified. Although settlement tanks were used to remove sediment, many early residents remember rust and sand in the water supply. (Photograph by Fred S. Finch, US Bureau of Reclamation; courtesy of the Powell Museum Archives.)

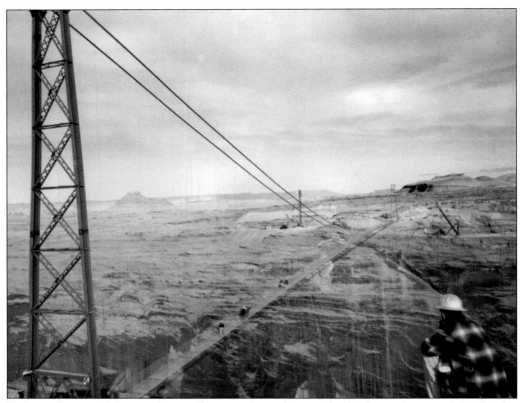

Early residents and dam workers walk across the pedestrian footbridge on January 4, 1958. Also known as the "chicken wire" or "swinging" bridge, it was erected by contractor Merritt-Chapman & Scott Corporation. Many early Page residents remember that the bridge would swing and bounce unsteadily while they walked across the canyon, especially on windy days or during work shift changes. (Photograph by A.E. Turner, US Bureau of Reclamation; courtesy of the Stan Jones Collection, Powell Museum Archives.)

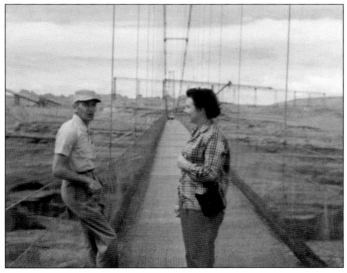

Stroudie (left) and Lillie Mae Gilleland (right) stand on the temporary wire footbridge suspended above the Glen Canyon Dam construction site in April 1959. The mesh bridge walkway allowed for minimal wind resistance, as well as a clear view of the canyon floor more than 700 feet below. (Courtesy of the Bruce and Marion Hart Collection, Powell Museum Archives.)

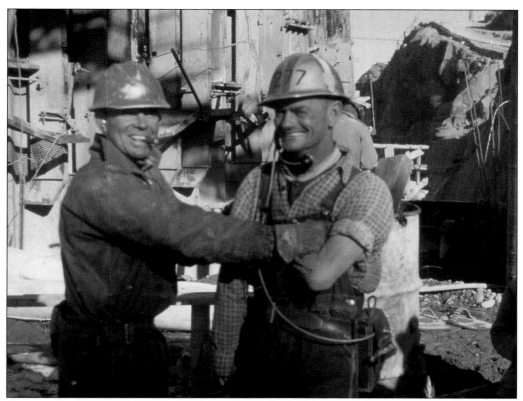

Communication was the key to worker safety and efficient work flow at the Glen Canyon Dam construction site. "Little Man" Bond and Carl Moody were bellboys (or signal men) working closely with cableway operators on the Glen Canyon Dam project. Carl Moody had a special hands-free headset developed specifically for the job because of a previous physical injury. (Courtesy of the Dick Kyle Collection, Powell Museum Archives.)

"Little Man" Bond and Roy Russell ride the spreader bar at the Glen Canyon Dam construction site. Materials were picked up on the canyon rim and delivered to the job site on the canyon floor using the spreader bar. Workers rode along with the load. (Courtesy of the Dick Kyle Collection, Powell Museum Archives.)

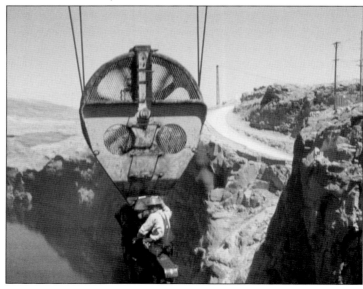

Merritt-Chapman & Scott Corporation (headquartered out of New York City) was the prime contractor for the construction of Glen Canyon Dam. Pictured in this January 9, 1959, photograph, its main office for the Glen Canyon Dam project was located on the west side of Glen Canyon. (Photograph by A.E. Turner, US Bureau of Reclamation; courtesy of the Powell Museum Archives.)

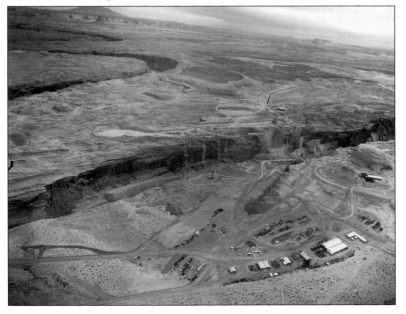

Seen here on October 4, 1958, a concrete batch plant (designed by the Nobel Company) on the west side of the Glen Canyon dam site supplied concrete for the dam's massive block foundation and structure. (Photograph by the US Bureau of Reclamation; courtesy of the Powell Museum Archives.)

Many Glen Canyon Dam workers, contractors, and their families ate at the mess hall on the West side of Glen Canyon. Early on, the mess hall was also used for church services, club meetings, dances, movie showings, and other community gatherings. (Photograph by the US Bureau of Reclamation; courtesy of the Powell Museum Archives.)

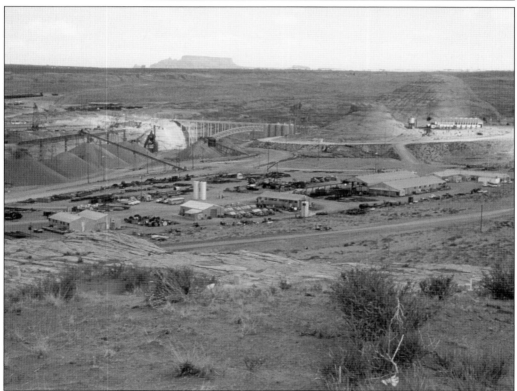

The west side construction camp was initially established to accommodate workers and equipment coming from Utah and the west side of Glen Canyon prior to the completion of the Glen Canyon steel arch bridge. A mesh cage suspended from cables and a temporary pedestrian bridge allowed access to both sides of the canyon. (Courtesy of the Dick Kyle Collection, Powell Museum Archives.)

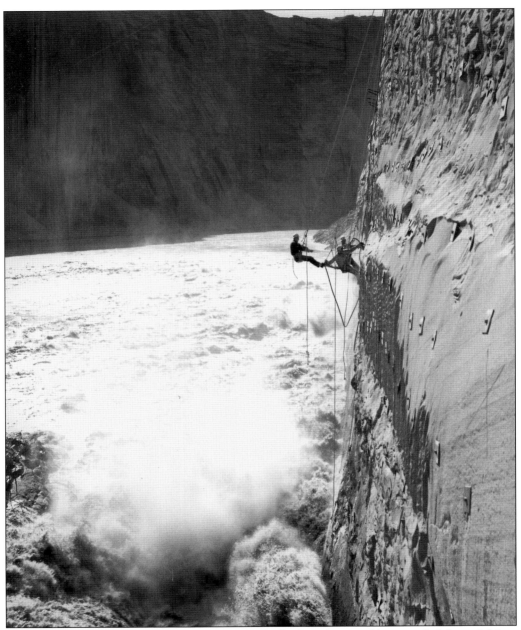

To make the canyon safer for workers below, daring high-scalers pried loose rock slabs and debris from the sandstone walls near Glen Canyon Dam site and inserted rock bolts into the cliffs to prevent new rock spalls from occurring. Seen here on April 5, 1960, the workmen dangled from ropes and cables secured 700 feet above on the canyon rim, carrying with them crow bars and jack hammers. Dynamite was used to break loose larger rocks, sending the boulders hurtling hundreds of feet to the canyon floor. Armed with only a hard hat, the danger from falling rocks, work equipment, and tools was an extreme and common threat. The hazardous conditions and physically demanding work of a high-scaler attracted a special group of willing men. (Photograph by A.E. Turner, US Bureau of Reclamation; courtesy of the Powell Museum Archives.)

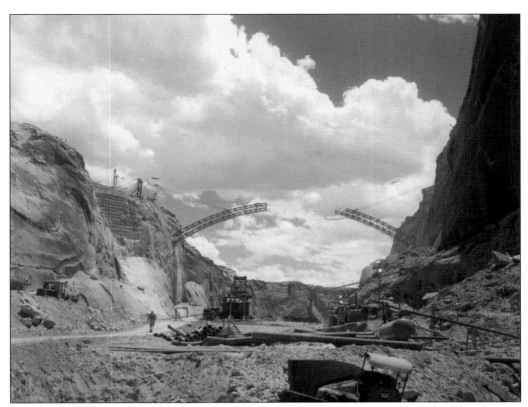

The Judson Pacific-Murphy Corporation was awarded the contract to construct the Glen Canyon steel arch bridge, and William Choate was selected as the project superintendent. In this July 15, 1958, photograph, prefabricated segments are being lowered by trolley cranes. Steelworkers bolted and riveted the sections together. (Photograph by J.L. Digby, US Bureau of Reclamation; courtesy of the Powell Museum Archives.)

The final cord on the Glen Canyon steel arch bridge is pictured here on August 6, 1958, as it is lowered into place. The world's highest steel arch bridge was opened to traffic in 1959 after bridge inspections by local inspectors, such as Howard Perkins and Walter C. Chubbuck. (Photograph by J.L. Digby, US Bureau of Reclamation; courtesy of the Powell Museum Archives.)

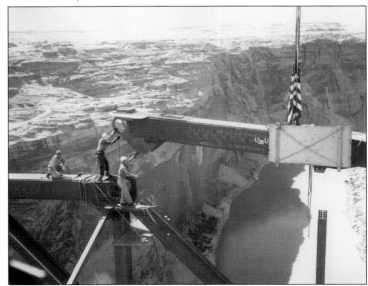

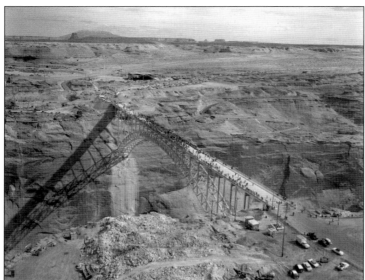

On February 20, 1959, Glen Canyon Bridge was dedicated and opened to the public. It connected the newly completed access roads on the Arizona and Utah sides of Glen Canyon. This picture was taken from the top of the "Beehive," a nearby natural rock formation. (Photograph by A.E. Turner, US Bureau of Reclamation; courtesy of the Powell Museum Archives.)

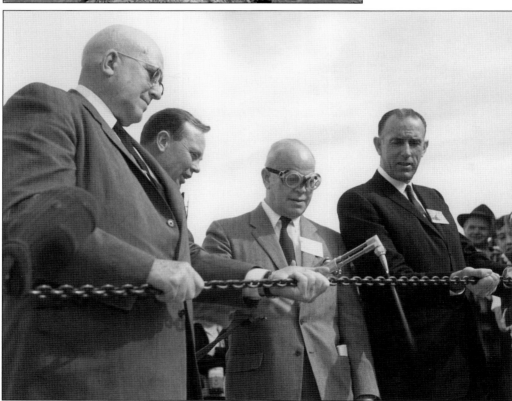

Utah governor George Clyde, US Bureau of Reclamation commissioner Wilbur A. Dexheimer (pictured here on February 20, 1959, cutting the ceremonial chain), and Arizona governor Paul Fannin were among the hundreds of people who attended the Glen Canyon Bridge dedication ceremony. (Photograph by A.E. Turner, US Bureau of Reclamation; courtesy of the Powell Museum Archives.)

Prior to the construction of Glen Canyon Dam, the Colorado River waters had to be diverted. Seen here on February 4, 1959, two cement-lined diversion tunnels with a diameter of 41 feet each were built into the canyon walls to carry water around the dam site. (Photograph by A.E. Turner, US Bureau of Reclamation; courtesy of the Powell Museum Archives.)

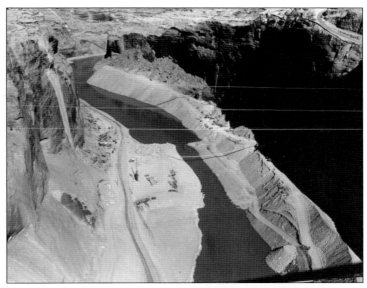

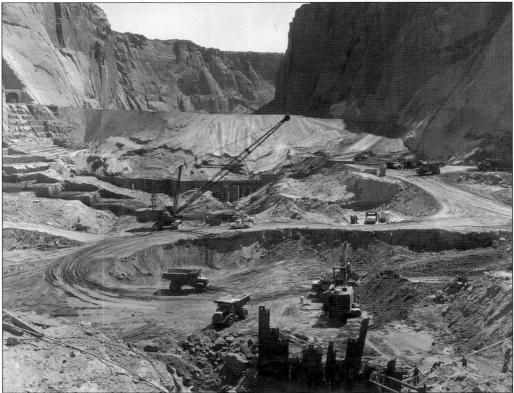

Seen here in this March 24, 1960, photograph, earthen cofferdams and diversion tunnels channeled the Colorado River flow around excavation work for the foundation of Glen Canyon Dam and power plant. Rock, sand, and gravel had to be removed from the canyon floor to expose bedrock, which would receive the first blocks of concrete. (Photograph by A.E. Turner, US Bureau of Reclamation; courtesy of the Powell Museum Archives.)

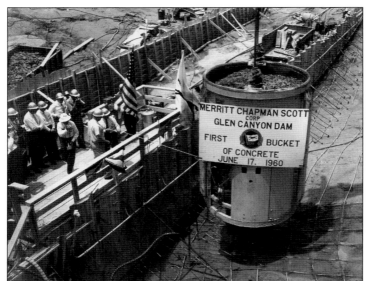

A processing plant was constructed approximately six miles from the dam site to supply aggregate for cement. A mixing plant and water refrigeration plant were also located on the rim of Glen Canyon. Merritt-Chapman & Scott Corporation poured the first bucket of concrete for Glen Canyon Dam on June 17, 1960. (Photograph by H. Fink, US Bureau of Reclamation; courtesy of the Powell Museum Archives.)

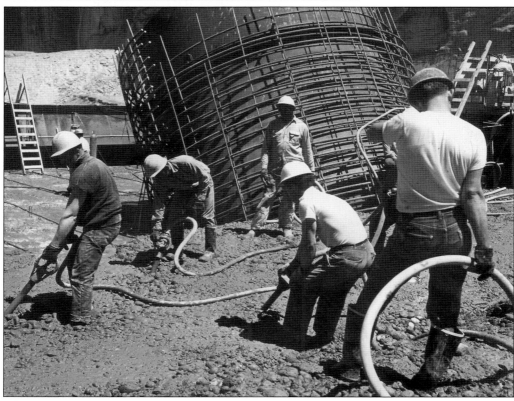

The elaborate and multi-faceted process of mixing and placing concrete also included the painstaking job of removing air pockets, leveling, washing, and keeping the mixture at a constant temperature as it dried and cured. Workers are pictured here on May 8, 1961, moving concrete into place in one of the foundation blocks at Glen Canyon Dam. (Photograph by A.E. Turner, US Bureau of Reclamation; courtesy of the Powell Museum Archives.)

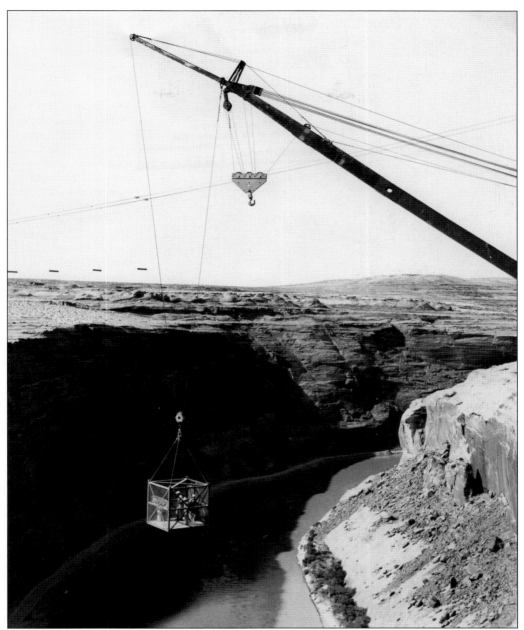

Workmen on the Glen Canyon Dam project were lowered over 700 feet into the canyon in a wire cage suspended from cliff-top booms and cables or by personnel elevators, also called "monkey-slides." Multiple elevators operated by electrical controls were located on both sides of the canyon and were lowered and raised by cable and wheel systems or steel channel-iron rails. On the east side of the canyon, men were bused from the town of Page to the rim of Glen Canyon, where they could access the cage and elevators and be shuttled to the canyon floor. The men also used the cage to cross the river before the foot bridge was completed, as well as during the construction of the steel arch bridge. (Photograph by A.E. Turner, US Bureau of Reclamation; courtesy of the Powell Museum Archives.)

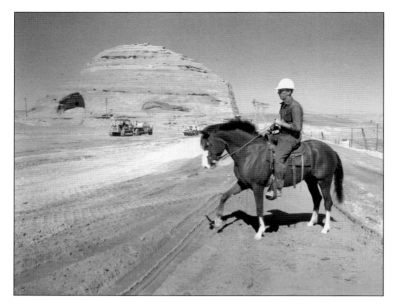

Two 345-kilovolt and one 230-kilovolt transmission lines from the Glen Canyon Dam switchyard reached Farmington, New Mexico, and Phoenix, Arizona. Fargo Brothers field superintendent Robert Irwin utilized a horse to make his rounds as he worked to expand the Glen Canyon Dam Switchyard on October 11, 1962. (Photograph by A.E. Turner, US Bureau of Reclamation; courtesy of the Powell Museum Archives.)

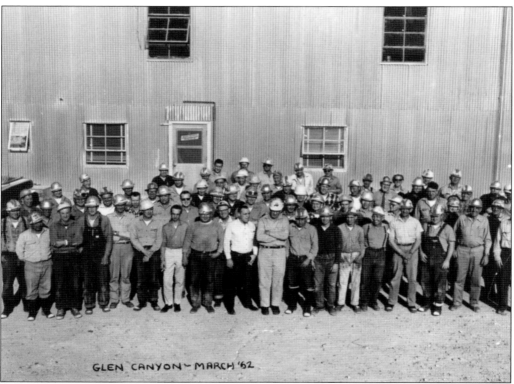

Shown here on June 18, 1962, are some of the thousands of men who worked on the Glen Canyon Dam project. However, despite an outstanding safety record for such a large project, 18 men were killed during the construction. A memorial was erected at the Carl Hayden Visitor Center to commemorate these individuals. (Photograph by A.E. Turner, US Bureau of Reclamation; courtesy of the Powell Museum Archives.)

A government car travels to the base of the Glen Canyon Dam construction site through the access tunnel at the canyon rim on May 18, 1960. The tunnel was used to transport materials and workmen to the construction site and was later used as a service road to the power plant. (Photograph by A.E. Turner, US Bureau of Reclamation; courtesy of the Powell Museum Archives.)

Nearly three million cubic yards of concrete were poured into the Glen Canyon Dam project when this photograph was taken on May 10, 1962. When the last bucket of concrete was poured on September 13, 1963, approximately five million cubic yards of concrete had been poured. (Photograph by A.E. Turner, US Bureau of Reclamation; courtesy of the Powell Museum Archives.)

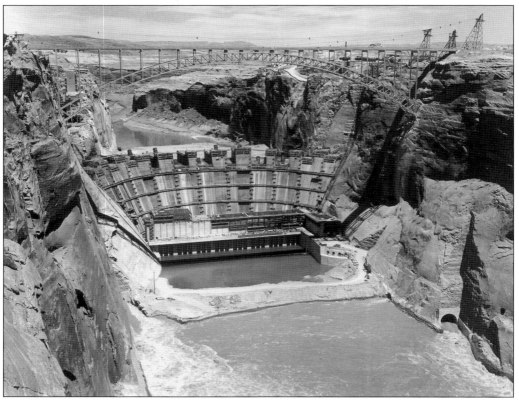

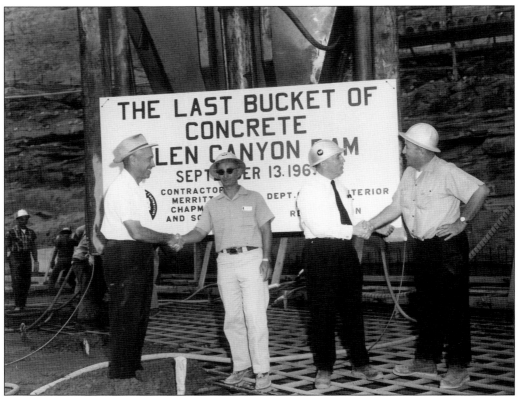

US Bureau of Reclamation construction engineer Lem F. Wylie, Merritt-Chapman & Scott Corporation general superintendent Curtis Glass, executive vice president for construction M.C. McGough, and Merritt-Chapman & Scott Corporation project manager James G. Irwin pose for a photograph at a ceremony celebrating the last bucket of concrete on September 13, 1963. (Photograph by Fred S. Finch, US Bureau of Reclamation; courtesy of the Powell Museum Archives.)

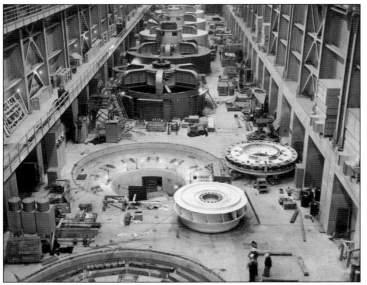

Workmen assembled eight generators inside the Glen Canyon Dam Power Plant to produce hydroelectric power. The first generator was tested in August 1964, and electricity was generated and transmitted for the first time on September 4, 1964. The power plant is seen here on February 17, 1965. (Photograph by Fred S. Finch, US Bureau of Reclamation; courtesy of the Powell Museum Archives.)

Two concrete-lined spillways on both sides of the dam empty into the lower ends of the diversion tunnels. Jim Harris (foreground) is pictured as he monitors concrete placed in the left spillway on July 20, 1966. (Photograph by Fred S. Finch, US Bureau of Reclamation; courtesy of the Powell Museum Archives.)

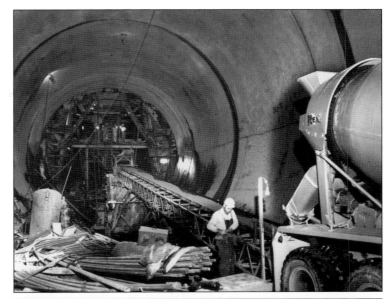

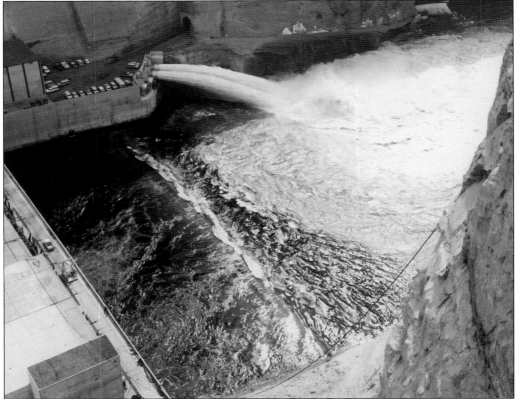

Glen Canyon Dam hollow jet tubes and valves control the amount of water released downstream from Lake Powell. The tubes were tested on April 20, 1965. Water released through the jet tubes bypasses the power plant and does not generate hydroelectric power. (Photograph by Fred S. Finch, US Bureau of Reclamation; courtesy of the Powell Museum Archives.)

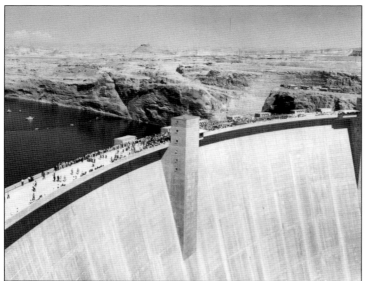

After 10 years of planning, design, and construction, Glen Canyon Dam was dedicated in front of thousands of onlookers on September 22, 1966. The event received national television and newspaper coverage. (Photograph by William A. Diamond, US Bureau of Reclamation, Howell R. Gnau Collection; courtesy of the Powell Museum Archives.)

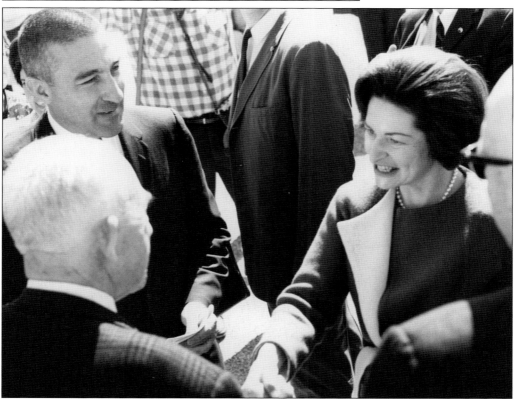

Many notable people attended the Glen Canyon Dam dedication ceremony, including secretary of the interior Stuart Udall (left), Arizona governor Sam Goddard, Utah governor Calvin Rampton, and Navajo tribal chairman Raymond Nakai. The dam was dedicated by First Lady "Lady Bird" Johnson (right) on September 22, 1966. (Photograph by William A. Diamond, US Bureau of Reclamation, Howell R. Gnau Collection; courtesy of the Powell Museum Archives.)

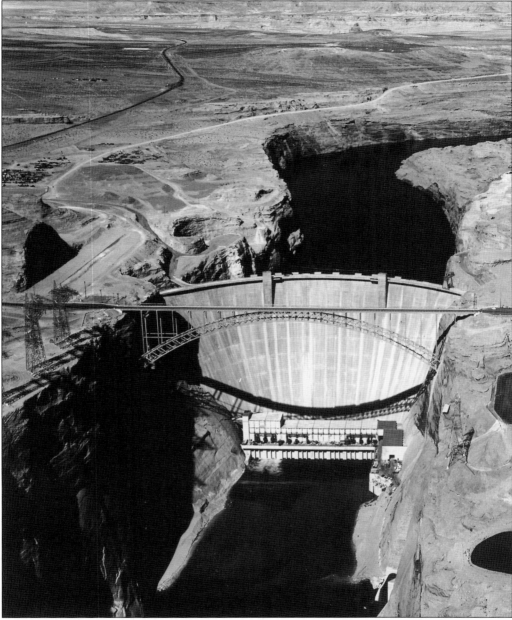

This October 21, 1964, aerial view of Glen Canyon Dam shows the lake filling behind the giant concrete structure. Not only does the dam produce hydroelectric power, but it also creates a reservoir for water storage needed for municipal and agricultural purposes, provides a means for flood control during years of increased precipitation, and creates a variety of recreational opportunities on Lake Powell. Eight generators in the Glen Canyon Dam Power Plant are capable of producing 1,320,000 kilowatts of hydroelectric power, providing electricity to millions of people living in the arid West. Steel towers standing more than 200 feet high accept high-voltage electricity from a switchyard near the dam, which is then distributed to various locations. (Photograph by Fred S. Finch, US Bureau of Reclamation; courtesy of the Powell Museum Archives.)

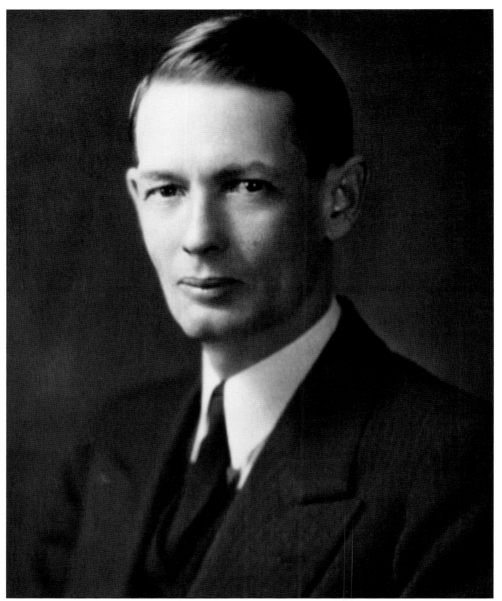

John Chatfield Page, the son of Walter Ernest and Emma Jerusha Page, was born on October 12, 1887, in Syracuse, Nebraska. He graduated from the University of Nebraska in 1908 with a bachelor of science degree in civil engineering and received a post-graduate diploma from Cornell University in civil engineering and hydraulics. John C. Page served as office engineer on the Hoover Dam project and was promoted to the post of manager of the engineering division of the US Bureau of Reclamation in Washington, DC, in 1936. Pres. Franklin D. Roosevelt appointed Page commissioner of the US Bureau of Reclamation in 1937. Bureau commissioner Wilbur Dexheimer named the town of Page for John C. Page as a tribute to his many years of devoted work on behalf of reclamation projects in the West. The name met with protests, as some wanted to name the town Glen Canyon City or Powell City. Dexheimer won, and Page found its way onto the maps. (Courtesy of the Jean Page Collection, Powell Museum Archives.)

Three

A Town is Born

By 1957, the Glen Canyon Dam construction camp had grown into a bustling town. It was populated by workers and government officials who needed the goods and services that new merchants provided. Everyone in the growing town of Page depended on each other in one way or another. The newly created merchant sector's success depended completely upon the needs and incomes of dam construction workers, contractor employees, and US Bureau of Reclamation officials. At that time, the Page area did not have the tourist traffic the town would see after Lake Powell started to fill.

Many of the businesses and residences were set up in trailers until permanent buildings could be built. The people of Page had an extraordinary willingness to help their neighbors, and many of the clubs, churches, and community buildings were built through countless volunteer hours and donated materials.

In the remote town, entertainment was at a minimum; however, the creativity of its residents ran strong. A teen center, drive-in movie theater, bowling alley, baseball field, golf course, library, and swimming pool were among some of the first recreational outlets created by residents. A school grew along with the burgeoning child population, and health care facilities were available almost immediately, including a modern 25-bed hospital. Transportation to and from the area was a challenge. Medical emergencies that could not be handled by local staff were flown to Flagstaff by the only contracted pilot in town.

In 1959, labor issues led to a strike against Merritt-Chapman & Scott Corporation, as workers demanded better wages to live in such a remote area. Workers left town, often taking their families with them. They took their money with them, too, leaving merchants without their business. Some merchants closed and left along with the workers, but those hardy enough to weather the storm were rewarded with the best Christmas present the town of Page had ever received—an end to the strike on Christmas Eve, six months after it began. The town was back in business.

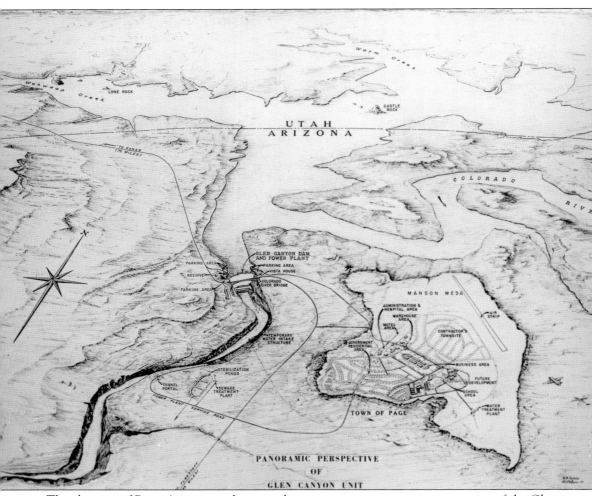

This drawing of Page, Arizona, and surrounding area gives a panoramic perspective of the Glen Canyon Dam construction site, the general layout of the town of Page, and the Lake Powell area. The town was planned and built under the direction of the US Bureau of Reclamation with the understanding that there would be a lower rate of employee turnover if there were appropriate housing, schools, churches, businesses, and recreational opportunities. Sam Judd was selected as the town architect, and Elmer Urban was the unofficial town manager. In December 1957, Elmer Urban sent out a prospectus advertising for merchants in the remote region of northern Arizona. At first, businesses were selected by application after review and background check, as well as by a lottery system. This system lasted only about one year, after which businesses were left to healthy competition. (Prepared by W.M. Shideler and J.T. Vitaliano, 1959, US Bureau of Reclamation; courtesy of the Powell Museum Archives.)

Shown here on September 24, 1959, a sign located along Highway 89 welcomed visitors and new residents to Page, Arizona. Even at this early stage in development, the new town of Page (located near the future Lake Powell and Glen Canyon National Recreation Area) was poised to become a popular tourist destination. (Photograph by the US Bureau of Reclamation; courtesy of the Powell Museum Archives.)

Sparse accommodations and commodities were available in the town of Page in 1957. As pictured here on November 26, 1957, there were no trees or grass on Manson Mesa, and roads were not paved. A temporary landing strip (near what in now North Navajo Drive) allowed supplies to be brought in by plane. (Photograph by Fred S. Finch, US Bureau of Reclamation; courtesy of the Stan Jones Collection, Powell Museum Archives.)

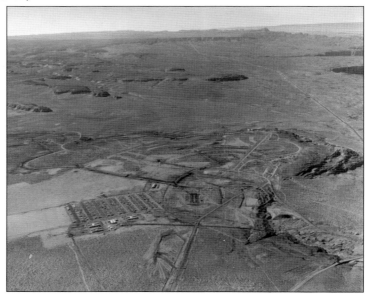

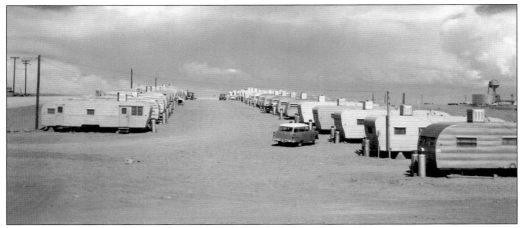

Workers and their families came from all over the world to work on the Glen Canyon Dam project. Trailer camps were set up for contractors and government workers in various locations on Manson Mesa and along the rim of Glen Canyon. The government camp seen here on August 18, 1958, was located on the southeast corner of Manson Mesa. (Photograph by A.E. Turner, US Bureau of Reclamation; courtesy of the Powell Museum Archives.)

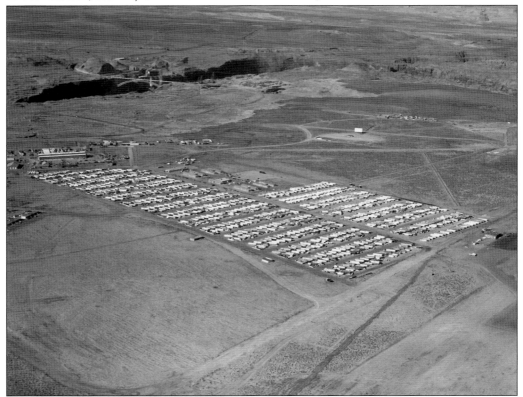

Managed by Earl Brothers, the Page trailer court was the largest trailer court in America at the time with approximately 900 trailers. Pictured here on December 14, 1960, the drive-in theater and rodeo grounds were located north of (behind) the trailer court. (Photograph by A.E. Turner, US Bureau of Reclamation; courtesy of the Powell Museum Archives.)

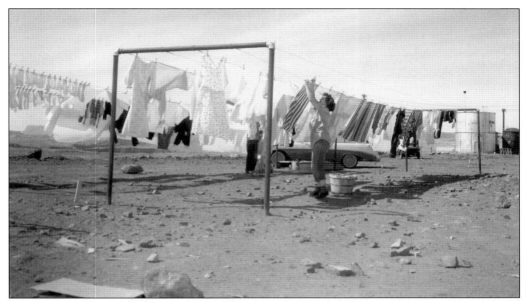

Early Page residents endured blowing and drifting sand in their homes, businesses, laundry, and drinking water. Mrs. Stanley Scow hangs out her laundry, which was often pink from sediment in the water supply and blowing sand, on March 10, 1958. (Photograph by A.E. Turner, US Bureau of Reclamation; courtesy of the Powell Museum Archives.)

In 1957, a makeshift basketball court was paved with sand. Steven LeClane, Howard and John Perkins, and Paul, Jime, and Mack Page engage in a game of basketball behind the Transa-houses on Manson Mesa on December 14, 1957. (Photograph by A.E. Turner, US Bureau of Reclamation; courtesy of the Powell Museum Archives.)

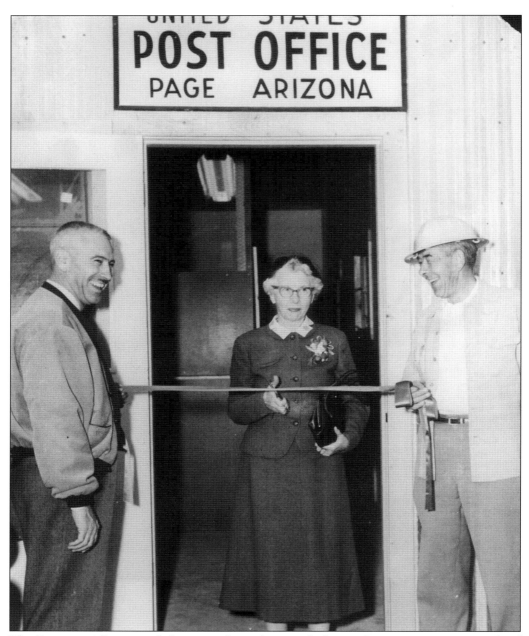

The Page post office provided some early residents with their only communication outside of Page, Arizona. News from family and friends, supplies, medicine, and library books were flown into Page through the United States Postal Service and a contract with Royce and Dora Knight (who also owned and operated the Page Airport). The first post office was temporarily located in a section of a metal Butler building in the Page business district. Kay Pulsifer served as the first postmistress. Glen Canyon Dam project construction engineer Lem F. Wylie (left); Mildred Page, widow of John C. Page (center); and Herbert Booth are pictured at the official opening of the post office on October 12, 1957. (Photograph by US Bureau of Reclamation; courtesy of the Powell Museum Archives.)

Shown here on September 13, 1957, the first bank in Page was temporarily housed in a trailer. It was later moved to a metal Butler building—near the post office, barbershop, gas station, and Babbitt's grocery store—until a permanent building was constructed. (Photograph by J.H. Enright, US Bureau of Reclamation; courtesy of the Powell Museum Archives.)

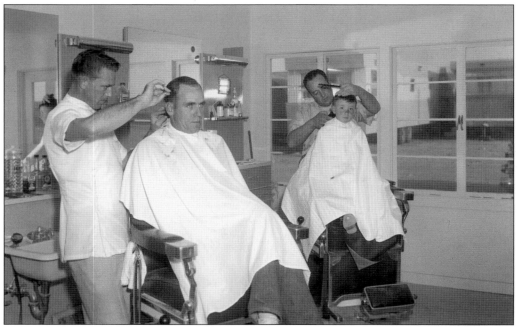

James Patterson (far left) trims Bob Upton's hair while barbershop proprietor Eugene Holder (right) cuts young Terry Holland's hair. The shop was located in the same metal building as the post office, gas station, and Babbitt's grocery store. (Photograph by A.E. Turner, US Bureau of Reclamation; courtesy of the Powell Museum Archives.)

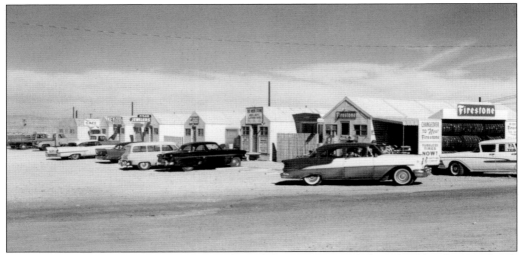

As seen in this February 3, 1959, photograph, early businesses—including the Glen Canyon Steak House Café, several clothing stores, a jewelry store, a shoe store, and a Firestone tire store—lined a windswept sand street in Page, Arizona. (Photograph by the US Bureau of Reclamation; courtesy of the Marjorie Doland Collection, Powell Museum Archives.)

The first businesses in Page, Arizona, were temporarily set up in metal Quonset hut–style buildings (also called Butler buildings). In 1957, the business district was located near the intersection of North Navajo Drive and Seventh Avenue. (Courtesy of the Bruce and Marion Hart Collection, Powell Museum Archives.)

Operated by George and Eula Koury, Babbitt's Market was initially located in the contractor's area. A semi-permanent building, it was erected by the prime contractor for the Glen Canyon Dam project, Meritt-Chapman & Scott Corporation. The store was owned by the Babbitt Brothers Trading Company, which was based out of Flagstaff, Arizona. (Courtesy of the Bruce and Marion Hart Collection, Powell Museum Archives.)

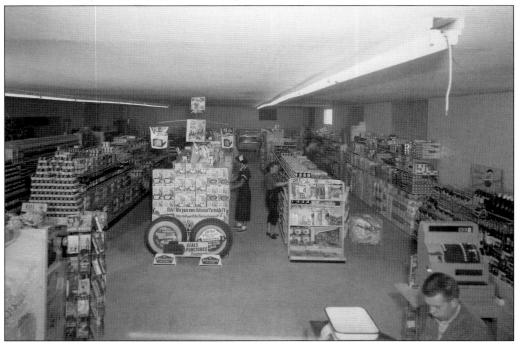

George and Eula Koury ran Babbitt's Market and were known for their generous nature. During the Glen Canyon Dam strike, George often extended credit to families who had little or no income. This October 18, 1957, photograph shows the interior of Babbitt's Market. (Photograph by A.E. Turner, US Bureau of Reclamation; courtesy of the Powell Museum Archives.)

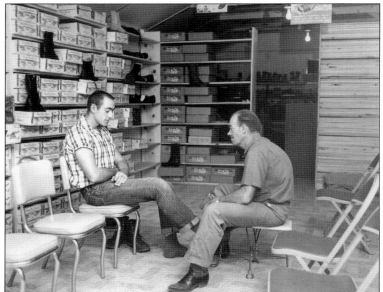

Cleo Collins is fitted with a pair of boots at the Page Family Shoe Store by Grant Jones on August 27, 1958. The store catered to construction workers and primarily provided men's work shoes and boots. (Photograph by J.L. Digby, US Bureau of Reclamation; courtesy of the Powell Museum Archives.)

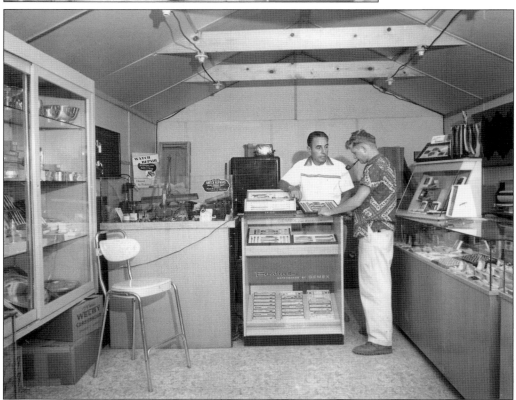

Ernie Severino assists US Bureau of Reclamation photographer James Digby as he inspects merchandise at the Page Jewelers store (located in the early business district) on August 27, 1958. (Photograph by A.E. Turner, US Bureau of Reclamation; courtesy of the Powell Museum Archives.)

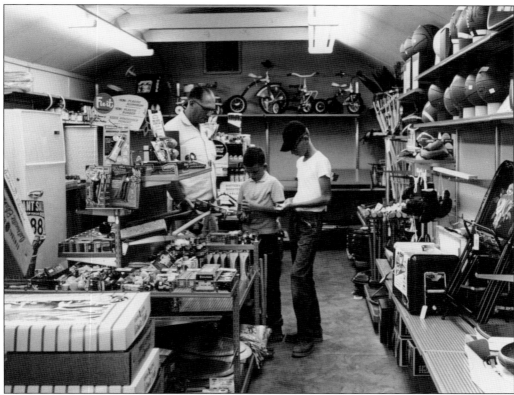

Before he ran the Richfield gas station, Lawrence K. O'Neill (standing behind the counter) ran the Western Auto hardware store (1958). O'Neill also served on the town of Page's first city council (1975) and became the second mayor of the city of Page (although he was the first mayor by ballot). (Photograph by the US Bureau of Reclamation; courtesy of the Powell Museum Archives.)

Ruby Proctor (left) was the first customer to be waited on by owner Al Roueche (center) at Page Market's new location in the Adkinson Mall business district on Elm Street on December 6, 1960. (Photograph by A.E. Turner, US Bureau of Reclamation; courtesy of the Powell Museum Archives.)

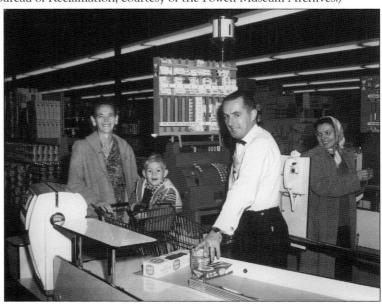

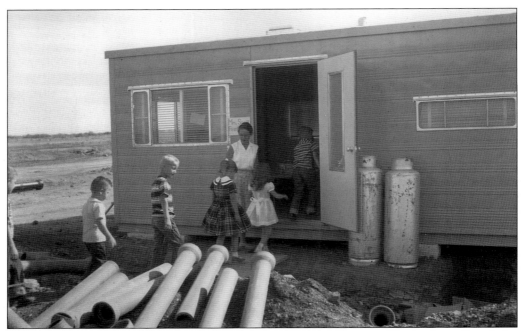

First graders attended school in a Transa-home that was used as a classroom. Teacher Janet Scott helps the children cross a sewer ditch safely as they arrived to class on September 13, 1957. (Photograph by J.H. Enright, US Bureau of Reclamation; courtesy of the Powell Museum Archives.)

The first Page teachers were Steve O'Brien and husband and wife teams Henry and Mary Howe and Raymond and Janet Scott. Dr. Lewis McDonald (pictured), the first school superintendent of Page, took a leave of absence from his work at Northern Arizona University to start the town's schools in 1957. (Photograph by the US Bureau of Reclamation; courtesy of the Bruce and Marion Hart Collection, Powell Museum Archives.)

Bus driver Mrs. Edison picked up children from the Page schools at the end of the day and took them to the Coppermine area and various government and contractors' camps. (Photograph by A.E. Turner, US Bureau of Reclamation; courtesy of the Powell Museum Archives.)

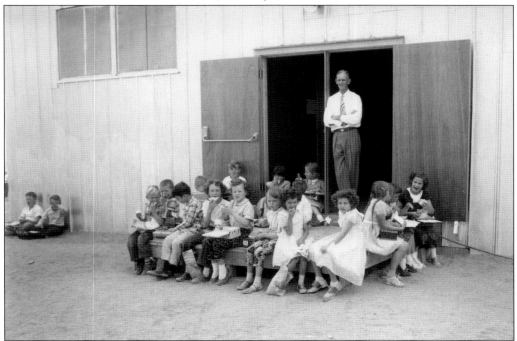

The first school was located in a Butler building, which was divided into four classrooms and an office. By February 1958, there were three Butler buildings used for school classrooms. Teacher Henry Howe stands in the doorway of one of the buildings and watches over the schoolchildren at lunchtime on September 30, 1957. (Photograph by Fred S. Finch, US Bureau of Reclamation; courtesy of the Powell Museum Archives.)

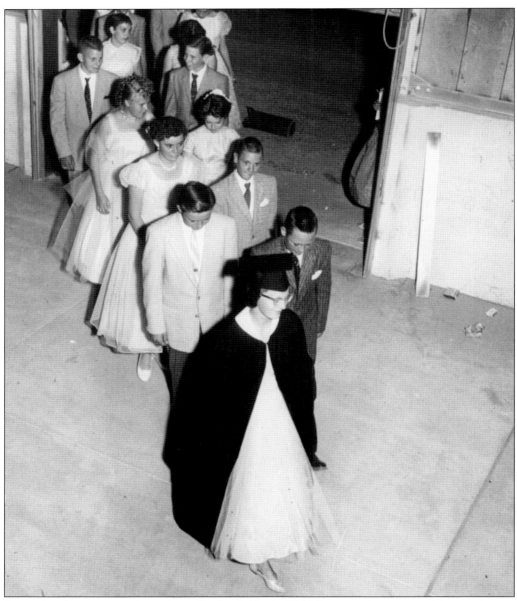

Coconino County superintendent of schools Bessie Kidd Best was instrumental in starting an accommodation school for Glen Canyon Dam construction workers' families in Page, Arizona. Dr. Lewis J. McDonald started the first Parent Teacher Association, with the help of Percy Marks, in 1957. McDonald served as the first Page school superintendent from July 1957 to January 1958, when Roy Gilbert took his place. Donna Taylor (pictured in the cap and gown on May 28, 1958) and Barbara Lovett (not pictured) were the only two graduating seniors from Page High School in 1958. Raymond Bradshaw became the third superintendent of Page schools in the fall of 1958 and stayed in that position until 1973. During the peak of construction work on Glen Canyon Dam, there were approximately 1,700 students enrolled in the Page School District. (Photograph by Fred S. Finch, US Bureau of Reclamation; courtesy of the Bruce and Marion Hart Collection, Powell Museum Archives.)

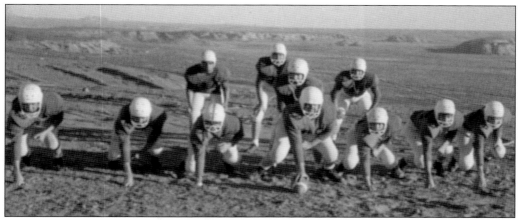

Members of the 1958 Page High School football team (from left to right) Roy Eaves, Glen Philips, Norris Daves, Eddie Jones, Ross Garner, Randy Garner, Ron Saber, Bill Wright, Gene Yerton, Jime Page, and Bob Patterson pose for a portrait on Manson Mesa. The first home football game was played on a plowed sand field with a set of portable bleachers to accommodate spectators. (Photograph by Jerry Jumper; courtesy of the Lillie Mae Gilleland Collection, Powell Museum Archives.)

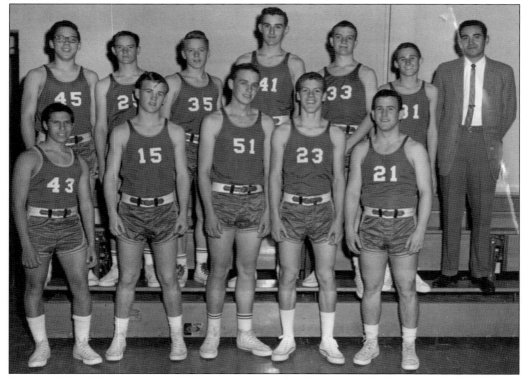

The Page High School basketball team competed for the first time in 1960, traveling long distances to meet their competition. The 1964–1965 varsity basketball team members pictured are, from left to right: (first row) Frank Leyba, Fay Heaton, Larry Zirker, Danny Chalmers, and Bill Harding; (second row) Dennis Karthauser, Ken Jacobsen, Myrlon Tenny, Mike Doland, Ed Robinson, Gary Bailey, and Jimmy Manriquez (coach). (Photograph by the US Bureau of Reclamation; courtesy of the Marjorie Doland Collection, Powell Museum Archives.)

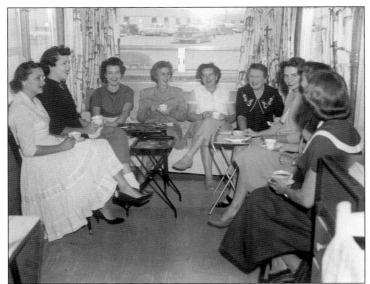

The first ladies coffee gathering was held at the trailer home of Charlene Gibson. Pictured here in the fall of 1957, from left to right, are Betty Settles, four unidentified, Mrs. Roper, Helen B. Smith, Louise Brothers, and Charlene Gibson. (Photograph by the US Bureau of Reclamation; courtesy of the Powell Museum Archives.)

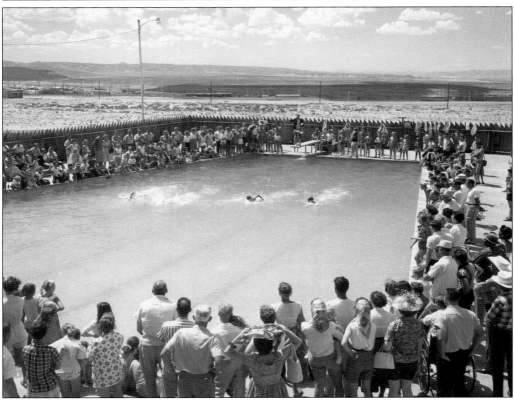

Manson Mesa Pool opened to the public on Saturday May 16, 1959, with a dedication ceremony presented by dam construction engineer Lem F. Wylie, dam project manager Al R. Bacon, and pool manager Steve O'Brien. Swimmers churn the water in one of the Fourth of July swimming competitions on July 4, 1959. (Photograph by A.E. Turner, US Bureau of Reclamation; courtesy of the Powell Museum Archives.)

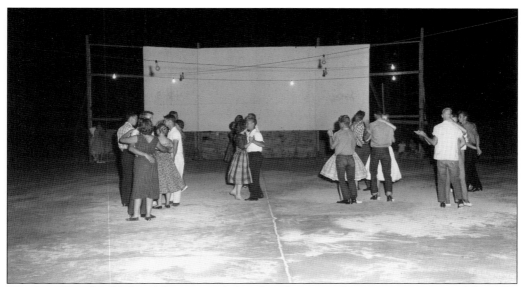

The Page Fourth of July celebration ended with a dance on the open-air concrete slab in the commissary area. The Teen Canteen's jukebox was used to play music for the dance. Page residents dance on the slab on July 4, 1959. (Photograph by A.E. Turner, US Bureau of Reclamation; courtesy of the Powell Museum Archives.)

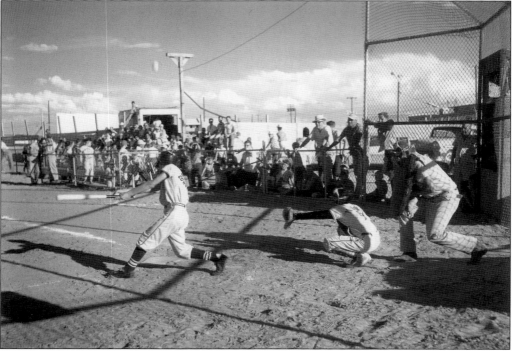

A little leaguer slams a foul ball at an exciting All-Star baseball game during the first citywide Fourth of July celebration on July 4, 1959. Unfortunately, the excitement would end just two days later when the Glen Canyon Dam strike began. (Photograph by A.E. Turner, US Bureau of Reclamation; courtesy of the Powell Museum Archives.)

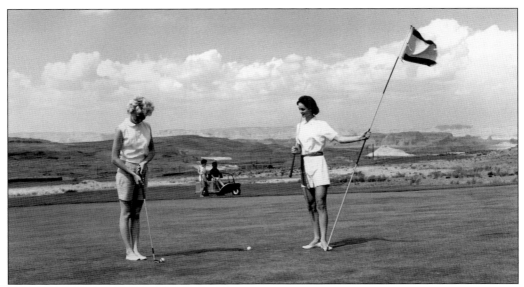

The nine-hole Glen Canyon Golf Course and Country Club was built using all volunteer labor. Glen Canyon Country Club president Vince Haight helped recruit volunteers and club members, and the golf course opened to the public in March 1959. Barbara Quast, Barbara Lovett, Pat Clausen, and Arthene Van Cleve play a round of golf on September 15, 1960. (Photograph by A.E. Turner, US Bureau of Reclamation; courtesy of the Powell Museum Archives.)

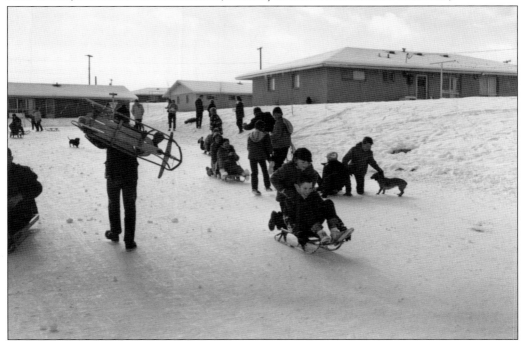

In 1961, a heavy snow blanketed the town just before Christmas, providing entertainment to many local children who took advantage of the winter playground. Children sled near Date Street on December 16, 1961. (Photograph by A.E. Turner, US Bureau of Reclamation; courtesy of the Marjorie Doland Collection, Powell Museum Archives.)

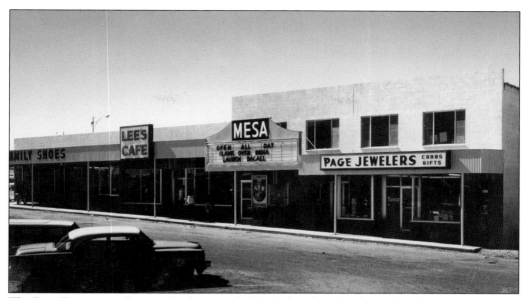

The Page Recreation Group raised money for Page's first drive-in theater by showing movies in a metal Butler building. Shown here on March 30, 1961, the Mesa Theatre opened with seating to accommodate 620 people. US Bureau of Reclamation ranger Raymond McAlister was commissioned to paint murals on the walls of the theater. (Photograph by A.E. Turner, US Bureau of Reclamation; courtesy of the Joyce Loshbough Collection, Powell Museum Archives.)

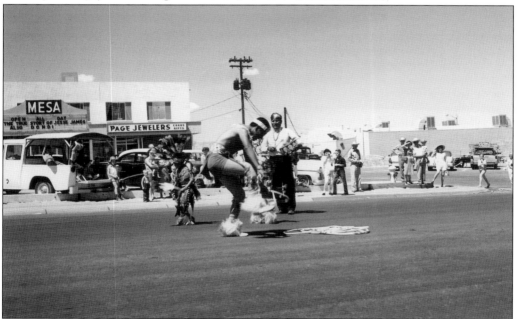

The Navajo Ceremonial Club sponsored Navajo Ceremonial Days from June 15 to June 17 in 1961. The celebration included a parade, Navajo Tribal Band performances, dances, ceremonies, and vendor booths, and attracted the largest group of spectators to the Page High School stadium to date. Spectators observe a traditional Navajo dance on June 17, 1961. (Photograph by A.E. Turner, US Bureau of Reclamation; courtesy of the Powell Museum Archives.)

Page started out as a dry town, meaning there was no alcohol available. Just after the end to the Glen Canyon Dam labor strike, Oscar Acedo (from Flagstaff, Arizona) unloaded the first delivery of beer to the 10-lane Canyon Lanes Bowling Alley, which was owned by Ted R. Selna. The strike lasted from July 6, 1959, to December 24, 1959. The dispute between five unions and the Merritt-Chapman & Scott Corporation centered on the lack of subsistence pay to workers living in a remote area. Many Page residents hosted impromptu parties and celebrated through the night when they received news that the 169-day strike was over. Firecrackers and the occasional celebratory gunshot could be heard across town. Work on the Glen Canyon Dam site resumed on January 4, 1960. (Photograph by A.E. Turner, US Bureau of Reclamation; courtesy of the Powell Museum Archives.)

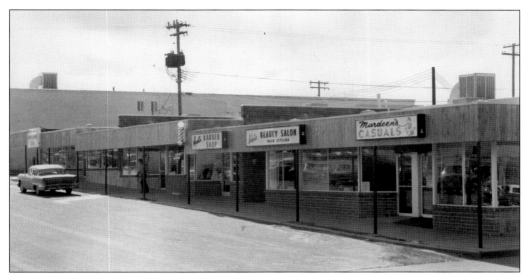

A women's clothing store, beauty and barbershop, furniture store, and a coin laundry occupied the Vista Shopping Center. Pictured here on February 14, 1962, the stores were located next to the Mesa Theater along Lake Powell Boulevard. (Photograph by A.E. Turner, US Bureau of Reclamation; courtesy of the Powell Museum Archives.)

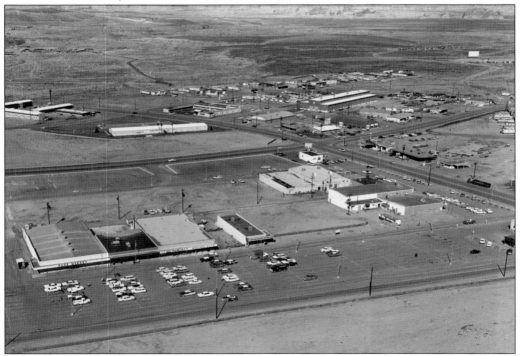

By 1963, several shopping centers had been built in downtown Page to accommodate the growing number of residents. In this February 13, 1963, photograph, Adkinson Mall is pictured (lower left) along Elm Street with Page Market, the post office, Ben Franklin, and Western Auto stores. The Vista Shopping Center is pictured (center) along Lake Powell Boulevard. (Photograph by A.E. Turner, US Bureau of Reclamation; courtesy of the Powell Museum Archives.)

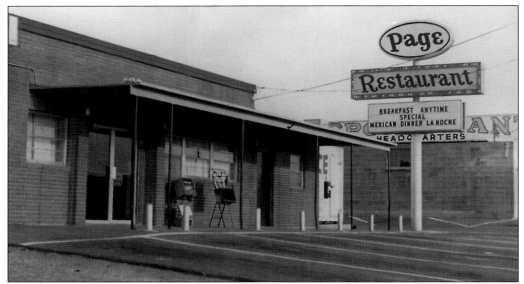

One of the first restaurants in Page was the Page Club on Lake Powell Boulevard. Owned and operated by Lloyd Porter, the restaurant and pool hall was a popular place for Glen Canyon Dam workers to relax and play pool—especially on payday. (Courtesy of the Powell Museum Archives.)

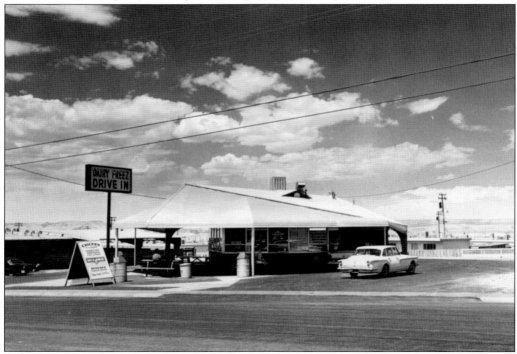

Page residents were able to experience the popular 1950s drive-in style eatery at the Pink Sans Drive-in, which was owned and managed by Leo Larson. The Pink Sans later became RD's Drive-in and was located on Lake Powell Boulevard. The local favorite is shown here on July 12, 1961. (Photograph by A.E. Turner, US Bureau of Reclamation; courtesy of the Marjorie Doland Collection, Powell Museum Archives.)

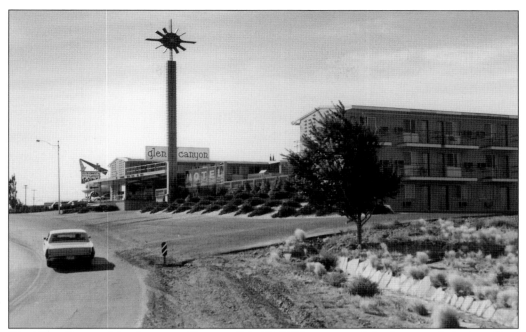

The Glen Canyon Motel, pictured here on July 27, 1967, was one of the first motels built in Page (along with the Page Boy Motel, Glen Page Motel, and the Empire House Motel). (Photograph by William A. Diamond, US Bureau of Reclamation; courtesy of the Powell Museum Archives.)

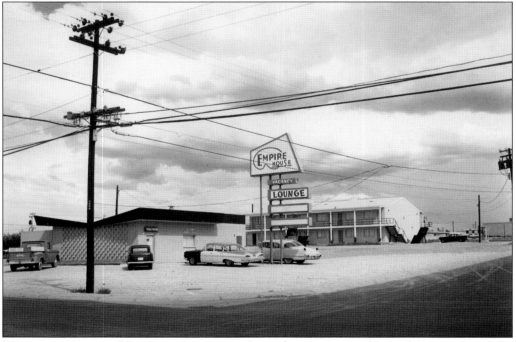

The Empire House and Toga Room Lounge were located on the corner of Seventh Avenue (now Lake Powell Boulevard) and Elm Street. This photograph was taken on September 28, 1960. (Photograph by A.E. Turner, US Bureau of Reclamation; courtesy of the Powell Museum Archives.)

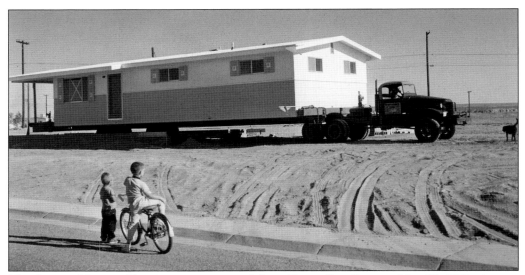

The first prefabricated home was transported from Flagstaff to Page on May 18, 1962. As new home construction struggled to keep up with demand, six prefabricated homes were moved to Page in 1962 to accommodate the growing number of people who needed housing. (Photograph by A.E. Turner, US Bureau of Reclamation; courtesy of the Powell Museum Archives.)

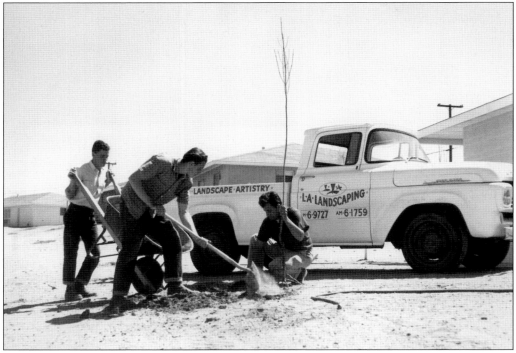

Workers for the landscaping contractor prepare to plant a tree in front of a government home. Rock outcroppings found under the sand-swept mesa proved to be a challenge when crews tried to plant trees symmetrically. Constant blasting from landscaping, the laying of home foundations, and water and sewer pipe installation could be heard around town. (Photograph by A.E. Turner, US Bureau of Reclamation; courtesy of the Powell Museum Archives.)

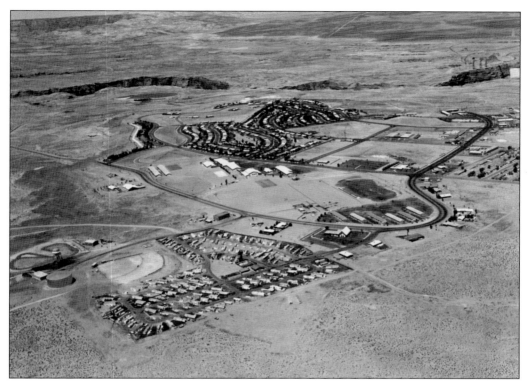

By 1966, eleven churches had been built in Page, including the First Baptist, Assembly of God, Catholic, Community Methodist, Episcopal, First Southern Baptist, Christian, Church of the Nazarene, Church of Christ, Church of Jesus Christ of Latter-Day Saints, and the Lutheran church. Most were built along Lake Powell Boulevard, which was referred to by locals as "Church Row." (Photograph by the US Bureau of Reclamation; courtesy of the Powell Museum Archives.)

This early residential area on North Navajo Drive included homes (built by the US Bureau of Reclamation) that housed Glen Canyon Dam workers, business owners, and their families. Page Airport operators Royce and Dora Knight and Page Shoe Store owners Grant and Flora Jones occupied two of the homes pictured. (Photograph by the US Bureau of Reclamation; courtesy of the Powell Museum Archives.)

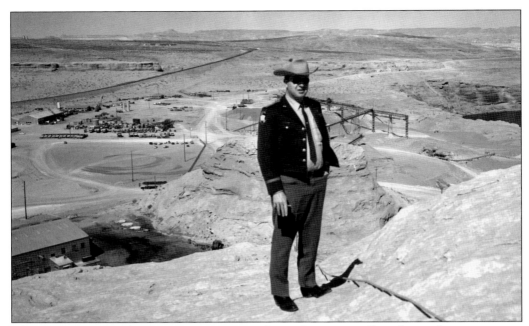

The US Bureau of Reclamation rangers oversaw law enforcement in Page during the construction of Glen Canyon Dam. Chief of police Don Kofford stands on the Beehive rock formation (near the Glen Canyon Dam construction site) in the 1960s. Highway 89 and Lake Shore Drive can be seen in the background. (Courtesy of the Powell Museum Archives.)

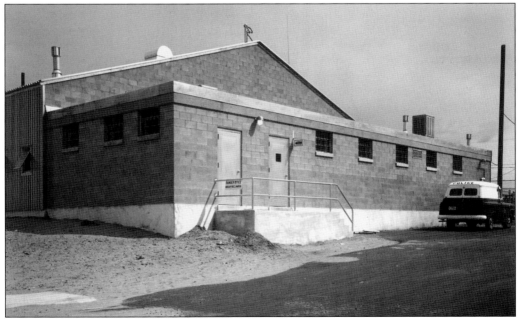

The Page police building housed the US Bureau of Reclamation ranger offices, communications center, and jail. Navajo police owned the vehicle that is parked outside of the building in this July 9, 1959, photograph. (Photograph by A.E. Turner, US Bureau of Reclamation; courtesy of the Powell Museum Archives.)

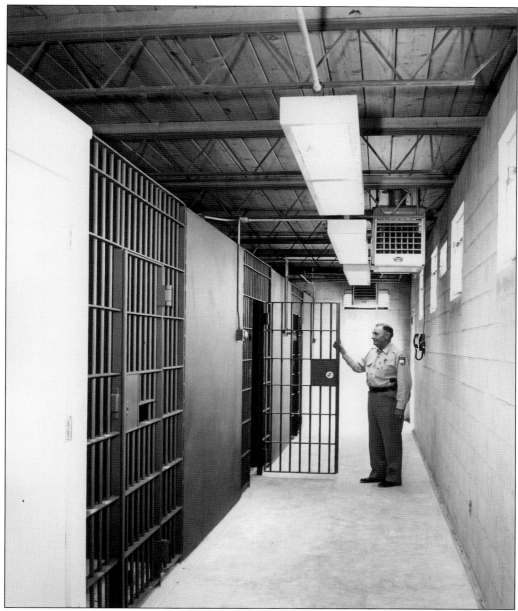

Construction engineer Lem F. Wylie recruited law enforcement officers for the Glen Canyon Dam project and transferred Michael Slattery (the first chief ranger from the Boulder Dam project) from Boulder, Nevada, to Page. The bureau rangers were responsible for keeping the peace on the Glen Canyon construction site and in town. Construction workers and their families were given a "one strike and you're out of a job" policy to deter mischief, theft, and violence. If a worker or a worker's family member was caught causing trouble, they were immediately asked to leave town. Pictured here on July 15, 1959, US Bureau of Reclamation ranger Bill Garrity inspects a jail cell in the police building. The majority of early disturbances in Page were due to excessive drinking or fighting. (Photograph by A.E. Turner, US Bureau of Reclamation; courtesy of the Powell Museum Archives.)

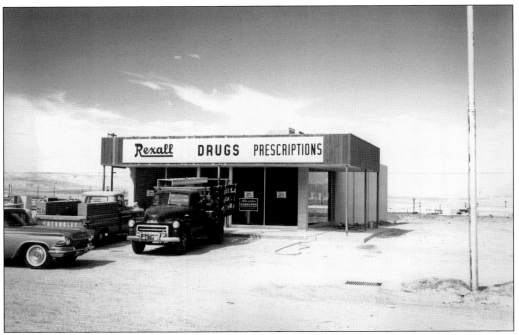

Page Rexall Drug Store (the first permanent building to be occupied in the Adkinson Mall shopping center) was owned and operated by Mack and Wanda Ward, who also ran the hospital pharmacy. Shown here on September 28, 1960, the drugstore was one of few businesses that stayed open during the Glen Canyon Dam strike, which lasted six months. (Photograph by A.E. Turner, US Bureau of Reclamation; courtesy of the Powell Museum Archives.)

Page Hospital was equipped with 25 beds, a laboratory, x-ray room, operating room, and delivery room. Two physicians, Dr. Ivan Kazan and Dr. J.B. Washburn, performed most of the medical and surgical procedures. This photograph was taken on June 28, 1961. (Photograph by A.E. Turner, US Bureau of Reclamation; courtesy of the Powell Museum Archives.)

Nurses at Page Hospital were in charge of managing the ambulance service for the town and construction site before the town was incorporated. Patients were transported to the hospital, where they were treated using state of the art equipment. Dr. Ivan Kazan (left) demonstrates how to operate new medical monitoring equipment at the hospital. (Courtesy of the Joy Collins Kazan Collection, Powell Museum Archives.)

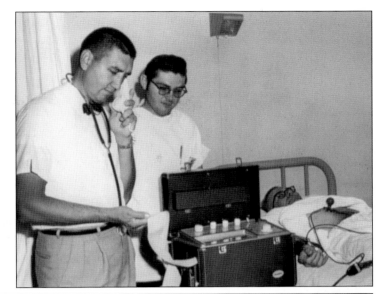

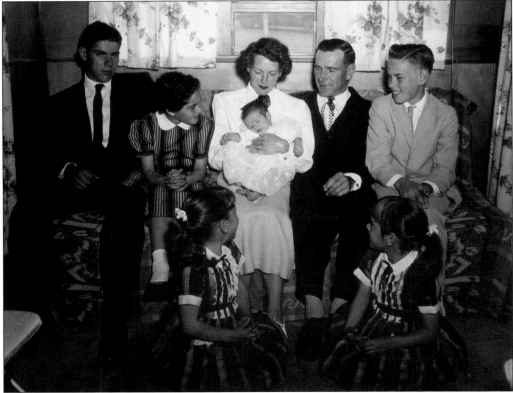

Mrs. Felix Saber gave birth to Cinci Marie, the first baby born in Page, Arizona. Felix Saber worked for Merritt-Chapman & Scott Corporation as a Glen Canyon Dam construction shovel operator. Pictured here on February 23, 1958 are, from left to right, the following: (first row) Donna and Dianne; (second row) Ron, Doris, Mrs. Saber, and Cinci Marie, Felix, and Tudy Saber. (Photograph by Fred S. Finch, US Bureau of Reclamation; courtesy of the Powell Museum Archives.)

Royce and Dora Knight built and operated the Page Airport. They offered charter and scenic flights, including shuttling mail, supplies, and people across Glen Canyon before the bridge was built. Shown here on March 15, 1967, the Page Airport was officially named the Royce K. Knight Field in 1988. (Photograph by William A. Diamond, US Bureau of Reclamation, Howell R. Gnau Collection; courtesy of the Powell Museum Archives.)

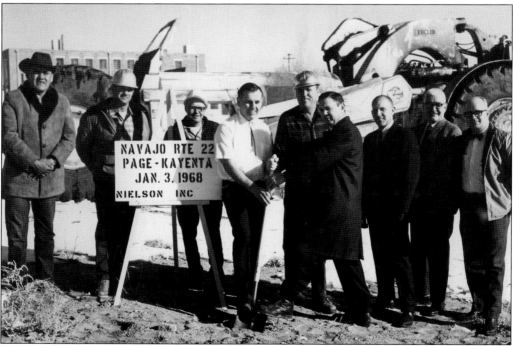

The ground-breaking ceremony for Navajo Route 22—a road built from Kayenta to Page, Arizona, that allowed much-needed access on the eastern side of the Navajo reservation—took place on January 3, 1968. Pictured at the ceremony, from left to right, are Pete Riggs (Navajo Tribal Council representative), Gene Cox (general superintendent for Neilson, Inc.), Jack Raley (project superintendent), William Warner (chamber of commerce president), Bill Nielson (construction company president), Jim Howell (Bureau of Indian Affairs officer), Dean Hall (Bureau of Indian Affairs chief engineer), Ed Lonergan (Page city administrator), and Mack Ward (chairman of the chamber of commerce highway committee). (Photograph by William A. Diamond, US Bureau of Reclamation; courtesy of the Powell Museum Archives.)

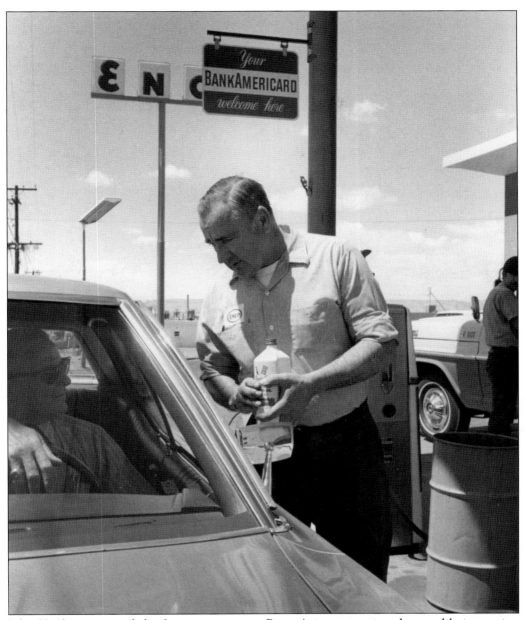

John Keisling operated the first gas station in Page, Arizona, serving the steadily increasing arrival of workers and families who moved to town. When Keisling first arrived in Page, he sold gasoline from the bed of a pickup truck and later in the temporary business district near Babbitt's Grocery and the post office. The more permanent Exxon Station gas station building was located on Lake Powell Boulevard. A second gas station opened in October 1958 and was owned and operated by Oscar and E. Mack Tenney. As more people became interested in the Glen Canyon Dam construction project and Glen Canyon National Recreation area, tourists began traveling to the remote town of Page. Quickly, services increased in response to the growing needs of the community and visitors. By 1969, there were seven service stations in Page. (Courtesy of the Mary Keisling Collection, Powell Museum Archives.)

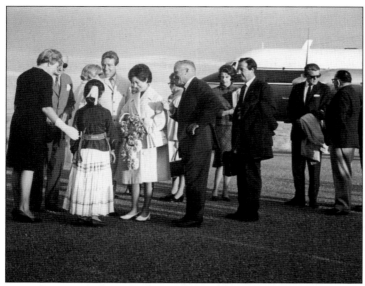

Princess Margaret and Lord Snowdon were welcomed by Rosa Acothley (in traditional Navajo clothing), Page Airport operators Royce and Dora Knight, and about 500 Page residents on their visit to Page, Arizona on November 13, 1965. (Photograph by the US Bureau of Reclamation; courtesy of the Powell Museum Archives.)

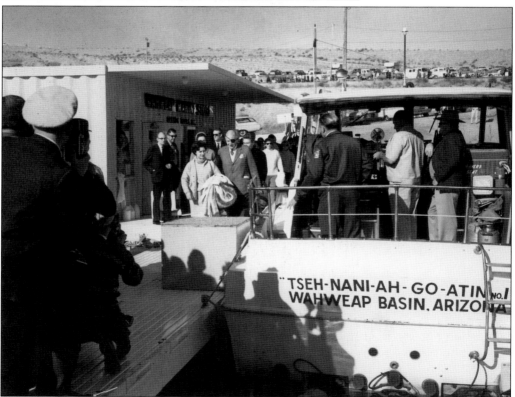

Princess Margaret boards a tour boat at Wahweap Marina on November 13, 1965. Art Greene (pictured far right) owned and operated Canyon Tours and Lake Powell Motel. Lewis Douglas, an investor for the Lake Powell Motel and former US ambassador to Great Britain, was host to the royal couple on their American tour. (Photograph by the US Bureau of Reclamation; courtesy of the Powell Museum Archives.)

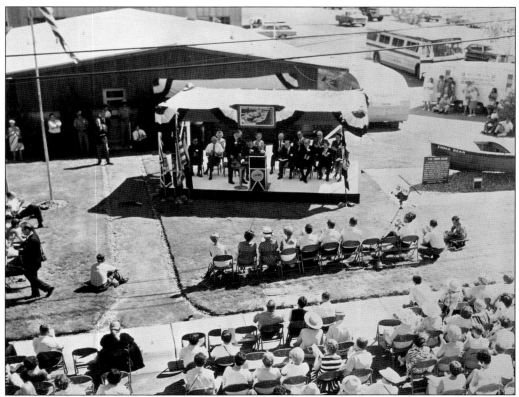

United States postmaster general Winton M. Blount dedicated a commemorative 6¢ stamp (designed by Rudolph Wendelin) commemorating the centennial of John Wesley Powell's 1869 expedition down the Green and Colorado Rivers on August 1, 1969. Descendants of the Powell family were in attendance at the dedication and official opening of the Powell Museum in Page, Arizona. (Courtesy of the Powell Museum Archives.)

Louise Davis (left) and Mary Alice Roberts, cochairmen of the Powell family reunion, wielded a giant pair of scissors to cut the ribbon officially opening the John Wesley Powell Memorial Museum on August 1, 1969. (Photograph by Stan Rasmussen, US Bureau of Reclamation; courtesy of the Powell Museum Archives.)

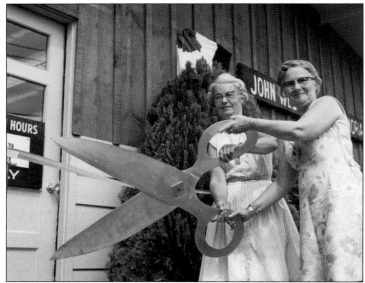

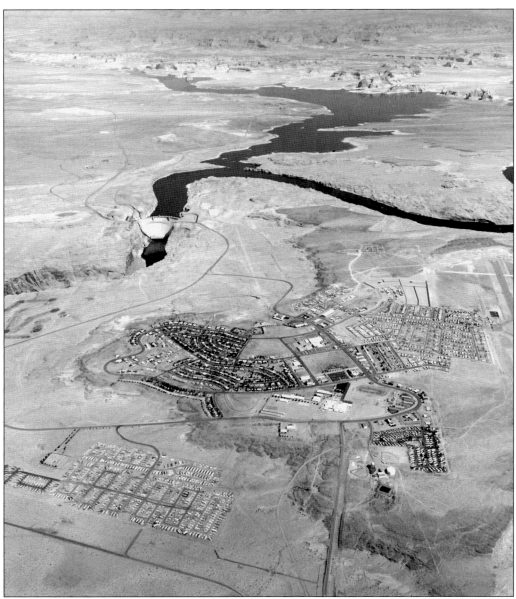

Water reclamation was the key to the early growth of the town of Page, seen here on May 16, 1973. However, after the completion of Glen Canyon Dam, there was a huge decline in the number of residents living and working in the area. Many dam workers moved around the country from job to job, following work wherever it would take them. The transient work force suited the needs of the contractors but left the town of Page without an important economic income. At the peak of construction in 1962, the town had approximately 6,100 residents. That number dwindled to about 1,250 residents in 1967. Although tourism was beginning to grow, it had not reached the point of sustaining the community of Page year-round. Another boom in population (because of the construction and management of the Navajo Generating Station in the 1970s) would bring jobs, services, and other opportunities back into the young community. (Photograph by the US Bureau of Reclamation; courtesy of the Powell Museum Archives.)

Four

BURSTING AT THE SEAMS

After the completion of the dam, the majority of construction workers and their families left for other projects. Over the next five years, Page's population dwindled, and businesses struggled to survive. Then, a growing demand for electric generation in the Southwest led to the evaluation, feasibility study, and (ultimately) the decision for the construction of a coal-fired generating station just east of Page on the Navajo Reservation. The location proved to be suitable for the needs of Salt River Project, and it also provided employment for the area. In 1970, ground-breaking ceremonies for the future home of the Navajo Generating Station took place. High-grade coal would be mined from nearby Black Mesa and shipped by train to the station. Water would be pumped from Lake Powell for use in the electrical generation process. The Navajo Generating Station would provide new life and vitality for the Page and Lake Powell area. Businesses, schools, and community municipal services would expand exponentially in order to accommodate the influx of people.

Housing was needed; often, there were waiting periods for new home construction, post office boxes, and other basic services. Despite apparent growing pains, Page flourished during the 1970s and 1980s. The town was incorporated as a city in 1975, and the Page Chamber of Commerce worked diligently to establish visitor interest in the Page and Lake Powell area and to attract new businesses, services, and employment. Visitation to Glen Canyon National Recreation Area increased annually, providing a much-needed economic boost for the community and a base for future tourism. In 1980, Lake Powell reached full pool of 3,700 feet above sea level. In 1983, excessive snow melt from the Rocky Mountains pushed lake levels to a record high of 3,708 feet, and the height of the dam's spillway gates had to be increased with reinforced steel extensions in order to keep water from spilling over.

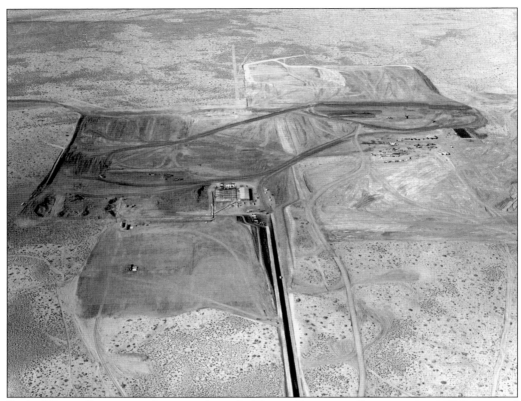

Bechtel Power Corporation began work on the Navajo Generating Station in April 1970. Pictured here on October 28, 1970, the coal-fired generating station was built with investment backing from the Los Angeles Department of Water and Power, Arizona Public Service Company, Nevada Power Company, Tucson Electric Power Company, US Bureau of Reclamation, and Salt River Project. (Photograph by the US Bureau of Reclamation; courtesy of the Powell Museum Archives.)

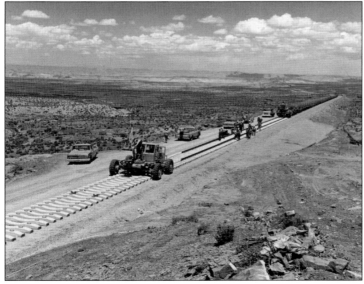

The Black Mesa & Lake Powell Railroad was constructed by the Morrison-Knudsen Company, Inc., to carry coal from the Kayenta Mine to the Navajo Generating Station. Initially, two trains would make six 156-mile round-trips each day. This photograph was taken on May 10, 1972. (Photograph by the US Bureau of Reclamation, Howell R. Gnau Collection; courtesy of the Powell Museum Archives.)

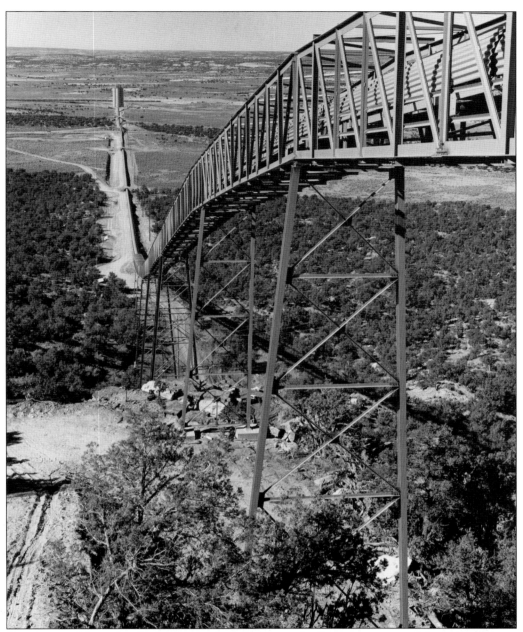

Seen here on November 14, 1973, a conveyor belt several miles long moves coal from the Kayenta Mine on Black Mesa to silos and the loading point in Klethla Valley, where the coal is transported by train to the Navajo Generating Station. The high-grade, low-sulfur coal is mined by Peabody Coal Company, providing approximately 7.5 million tons of coal annually to the Navajo Generating Station. Water pumped from nearby Lake Powell is used in the electricity production process. The Navajo Generating Station was constructed on land leased from the Navajo Nation after long negotiations with the Navajo and Hopi tribes. (Photograph by the US Bureau of Reclamation, Howell R. Gnau Collection; courtesy of the Powell Museum Archives.)

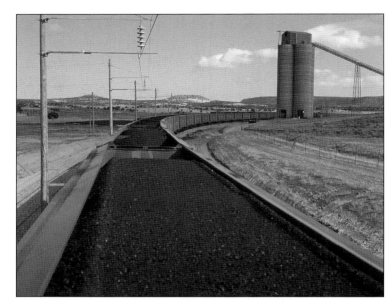

The loading and unloading of coal is done automatically by electronic control. General Electric Company locomotives pull bottom-dump train cars that carry nearly 122 tons of coal each. The Black Mesa & Lake Powell train ran on its own power for the first time in August 1973. (Photograph by Stan Jones; courtesy of the Powell Museum Archives.)

Shown in this July 18, 1973, photograph, the Black Mesa & Lake Powell Railroad was the first 50,000-volt electric railroad in the world. The high-voltage system eliminated the need for substations along the route. (Photograph by the US Bureau of Reclamation, Howell R. Gnau Collection; courtesy of the Powell Museum Archives.)

Construction of the Navajo Generating Station took six years to complete. The first unit began commercial operation in May 1974, the second unit in April 1975, and the third unit in April 1976. The official dedication of the 2.25-million-kilowatt station took place on June 4, 1976. (Photograph by the US Bureau of Reclamation, Howell R. Gnau Collection; courtesy of the Powell Museum Archives.)

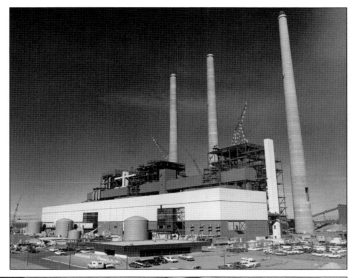

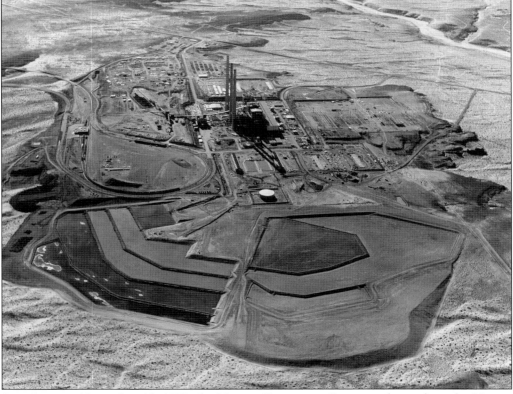

Seen here on November 15, 1973, the Navajo Generating Station is located on the Navajo Reservation approximately four miles from Page, Arizona. The station provides hundreds of permanent and temporary jobs to residents of Page, Arizona, and the Navajo Nation. It also increased the population and boosted the economy of the town of Page following the completion of Glen Canyon Dam. (Photograph by the US Bureau of Reclamation, Howell R. Gnau Collection; courtesy of the Powell Museum Archives.)

Previously a federal municipality, the town of Page was incorporated as a city in 1975. John C. Page's widow Mildred Page (right) and her daughter Millie Danielson gave the presentation of the official town flag to Page's first mayor, Norm Martindale (left), at the Page incorporation ceremonies on March 22, 1975. (Photograph by V. Jetley, US Bureau of Reclamation; courtesy of the Powell Museum Archives.)

Page and Kaibito schoolchildren perform at the Page incorporation ceremonies on March 22, 1975. The ceremonies were held at the Page High School auditorium and were broadcast live on the local radio station. (Photograph by V. Jetley, US Bureau of Reclamation; courtesy of the Powell Museum Archives.)

The US Bureau of Reclamation municipal building was turned into City of Page offices and city hall. Vostrom Industries, fourth- and fifth-grade elementary classes (temporarily), and the Page Public Library were also housed in the building at one time. (Photograph by William A. Diamond, US Bureau of Reclamation; courtesy of the Powell Museum Archives.)

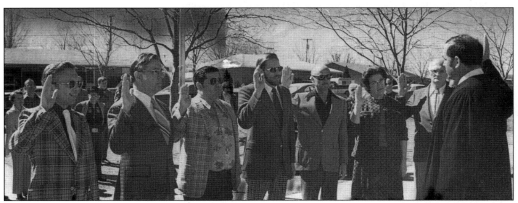

State Court of Appeals judge Laurance T. Wren gives the first Page City Council members the oath of office on March 1, 1975. From left to right are James Stubbs, William Warner, Lincoln Bichard, Norman Martindale, Elmer Urban, Marjorie Doland, and Lawrence K. O'Neill. After the swearing in ceremony, Norman Martindale was elected as mayor. Marjorie Doland was selected as mayor pro-tem. (Courtesy of the City of Page.)

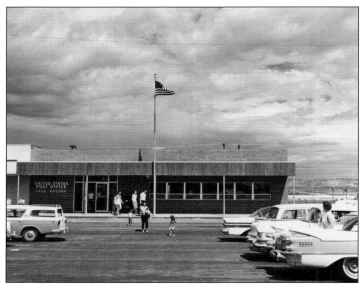

During the construction of the Navajo Generating Station, thousands of new residents waited in line at the post office to receive general delivery mail until new post office boxes could be installed to accommodate the growing community. Shown here on July 31, 1961, the post office was located on Elm Street in the Adkinson Mall shopping area. (Photograph by A.E. Turner, US Bureau of Reclamation; courtesy of the Powell Museum Archives.)

Page's first fire chief Byron Selvage organized an all-volunteer fire department. By April 1975, the Page Fire Department had two full time employees, Chief Bill Grigsby and Assistant Chief John Olson. Fireman Mike Taylor (far left) and Chief Jake Sisk (kneeling) visited the Lutheran Sunflower preschool during fire prevention week on October 10, 1979. (Photograph by Julia P. Betz, *Lake Powell Chronicle*; courtesy of the Powell Museum Archives.)

The chamber of commerce was established to promote businesses and tourism in the Page area. During the late 1970s and 1980s, new and established businesses tended to flourish as the town grew. They increasingly provided services to the Navajo Generating Station workers and their families. Pictured here in July 1980, Joan Nevills-Staveley (right) was appointed as the first director of the chamber of commerce and the Powell Museum. (Photograph by Julia P. Betz, *Lake Powell Chronicle*; courtesy of the Powell Museum Archives.)

Business owners and the Page Chamber of Commerce strived to make Page "the shopping center of the north." Shoppers stroll the Adkinson Mall business area in August 1980. It contained a variety of stores, such as a grocery store, clothing stores, and a drugstore. (Photograph by Julia P. Betz, *Lake Powell Chronicle*; courtesy of the Powell Museum Archives.)

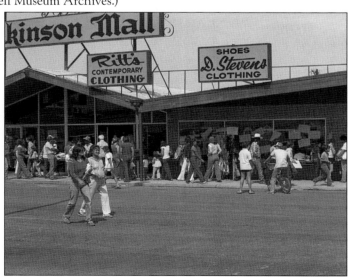

Ledora Kelly, who kept books in a shack next to her trailer home, provided the first volunteer library services in the late 1950s. Eventually, the library moved to the Page municipal building and then to the city hall office building. Volunteers ran the library until 1979, when the first full-time employee was hired. Librarian Tom Carollo reads a book during preschool story time in January 1981. (Photograph by Julia P. Betz, *Lake Powell Chronicle*; courtesy of the Powell Museum Archives.)

In 1972, there was a 300 percent increase in high school enrollment because of the construction of the Navajo Generating Station. In anticipation of county money from the station, a new high school was built with upgrades to the stadium and track areas. By 1978, an elementary school had been built, as well as a cafeteria and cultural arts building (pictured here in October 1983). (Photograph by Julia P. Betz, *Lake Powell Chronicle*; courtesy of the Powell Museum Archives.)

Communications in the growing city of Page were essential in the economic development of the area. Steve Paranto stands outside of the KPGE radio station (a 1,000-watt country, rock, and easy-listening station) in November 1981. A 3,000-watt FM station became available in Page in March 1982. (Photograph by Julia P. Betz, *Lake Powell Chronicle*; courtesy of the Powell Museum Archives.)

The *Lake Powell Chronicle* won seven state awards (four first and three second-place) from the Arizona Newspapers Association in 1981. Weekly newspaper staff members pose for a group photograph. From left to right are Ethel Davenport (receptionist), Carol Poore (advertising sales representative), Julia P. Betz (editor), Norma Stubbs (publisher), Everett Robinson (general manager), and James Stubbs (publisher). (Photograph by Merle A. Young, *Lake Powell Chronicle*; courtesy of the Powell Museum Archives.)

Many of the local events that started in the 1970s and 1980s are still part of an exciting citywide calendar of events. Some have led to other popular activities, such as the Page Balloon Regatta, which was indirectly derived from the Lake Powell Air Affaire. These events bring a sense of community and excitement to residents and visitors alike. (Photograph by Joan Nevills-Staveley; courtesy of the Powell Museum Archives.)

The Canyon King paddle-wheel boat was the site of many special events and provided hundreds of visitors with cruises on Lake Powell. The Canyon King leads the procession of decorated boats in the annual holiday Festival of Lights parade on Lake Powell in December 1984. The Festival of Lights later transitioned to a land-based parade through Page, Arizona. (Photograph by Steven F. Ward; courtesy of the Powell Museum Archives.)

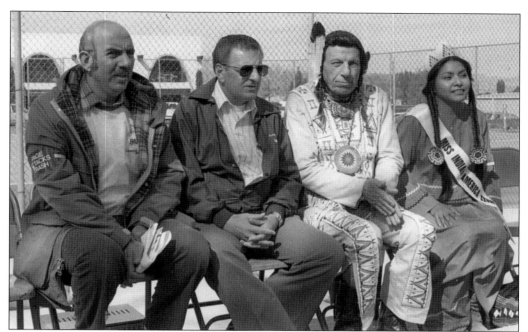

In 1981, Page Attacks Trash started as a one-day, annual trash-removal event sponsored by the Navajo Generating Station, the City of Page, Glen Canyon National Recreation Area, and the Navajo Nation. Pictured here in April 1984 are, from left to right, Dave Pape (mayor of Page), Jerry Jones, Iron Eyes Cody (a figurehead for the Keep America Beautiful campaign), and Vivian Juan (Miss Indian America). (Photograph by Carol Poore, *Lake Powell Chronicle*; courtesy of the Powell Museum Archives.)

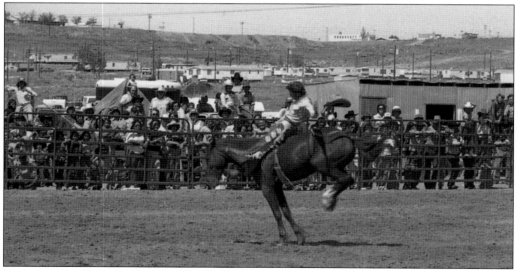

Beginning in 1960, the Page Saddle Club sponsored the annual Big Dam Rodeo. The popular community-wide event included a jackpot-roping contest (with prizes donated by local merchants), a parade, and an evening square dance. Arizona governor Jack Williams and his wife attended the rodeo at least once, and he served as the grand marshal of the rodeo parade. (Photograph by Julia P. Betz, *Lake Powell Chronicle*; courtesy of the Powell Museum Archives.)

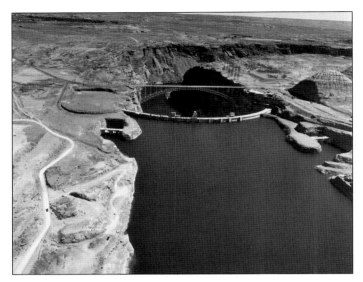

In 1983, several weather fronts brought large amounts of precipitation followed by warm weather, which caused flooding in Utah and Arizona. Glen Canyon Dam spillways were opened to release excess water, but the lake continued to rise. Eight-foot-high reinforced steel extensions were installed over each of the spillway openings to increase storage capacity. (Photograph by the Water and Power Resources Service; courtesy of the Powell Museum Archives.)

Lake Powell water levels reached record high elevations as runoff and flooding in Utah raised the lake level to 3,708 feet on July 14, 1983. Runoff above Lake Powell in 1983 totaled 20.5 million acre-feet, approximately 180 percent of average. This photograph was taken on July 15, 1983. (Courtesy of Glen Canyon National Recreation Area Archives.)

Five

THE COLORADO RIVER, LAKE POWELL, AND TOURISM

The Colorado River has dominated the northern Arizona landscape for thousands of years, slowly exposing geologic wonders along its course. Although the river hindered early land-based travel for all but the hardiest of adventurers, most of them did not come to cross the river—they came to utilize the river's resources and to conquer and explore. The first commercial white-water company, Nevills Expeditions, began introducing visitors to the wonders of Glen and Grand Canyons in the early 1930s, including taking the first women through the Grand Canyon in 1938. Many white-water entrepreneurs soon followed.

Lake Powell was officially born on March 13, 1963, when contractors sealed the diversion tunnels at Glen Canyon Dam. As the lake waters soon started to rise, so did tourism. The 44-room Wahweap Lodge (operated by Canyon Tours, Inc., and owned and managed by the Greene family) opened in 1960. The Wahweap Lodge, now operated by Lake Powell Resorts, has expanded to 350 rooms. Tour boats immediately began to introduce visitors to the wonders of the new lake, including the crowning attraction: Rainbow Bridge, a natural stone arch 290 feet high and spanning 234 feet. The resort's founder, Art Greene, started Colorado River tours from Lees Ferry in the 1940s (his family remains active in tourism on Lake Powell today). Lake Powell offers visitors a wide variety of activities, including boating, fishing, sailing, swimming, skiing, hiking, and camping. It has also become a foremost playground for amateur and professional photographers alike.

Norman D. Nevills's guided river trips laid an important foundation for the future of commercial river running. Beginning in 1936, Nevills organized trips down the San Juan River to Rainbow Bridge. Very often, the trips were a once-in-a-lifetime experience of adventure and exploration. Nevills made the first commercial run of the Colorado River in 1938. Dr. Elzada Clover, a botany professor from the University of Michigan, and her 24-year-old lab assistant Lois Jotter went on the trip to collect and study plants of the Grand Canyon region. The two women, who were paid passengers, were the first women to successfully complete a river trip through the Grand Canyon. Ed Olsen's short film *Facing Your Danger* featured one of Nevills's 1942 trips through the Grand Canyon and included scenes of camping, hiking, and running dangerous rapids. The film won an Academy Award for short subjects in 1946. Of the first 100 people to go through the Grand Canyon, almost half went with Nevills Expeditions. (Photograph by J.M. Eden, National Park Service; courtesy of the Powell Museum Archives.)

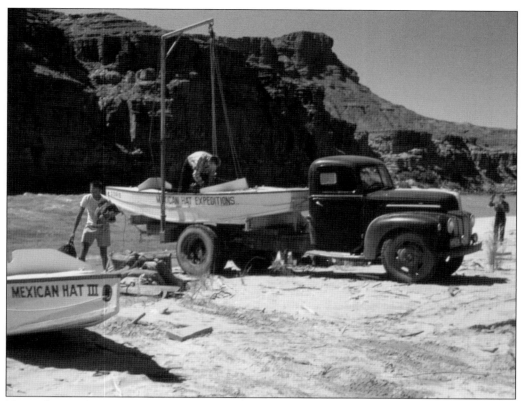

Norm designed and built what he called a "cataract" boat, seen here in this photograph from the summer of 1950. He led commercial trips, primarily on the San Juan and Colorado Rivers, until his death in 1949. His company, Nevills Expeditions, was based out of Mexican Hat, Utah. (Photograph by Esther Mallett; courtesy of the William and Eva Jones Collection, Powell Museum Archives.)

In 1949, Frank Wright and Jim Rigg took over Nevills's company and changed the name to Mexican Hat Expeditions. A group of river runners begin their Grand Canyon adventure at Navajo Bridge in Marble Canyon in the summer of 1950. (Photograph by Esther Mallett; courtesy of the William and Eva Jones Collection, Powell Museum Archives.)

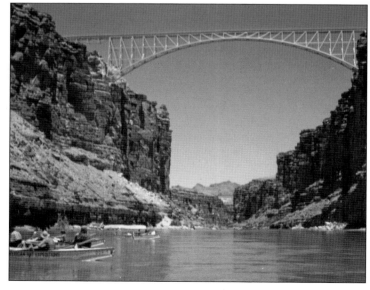

Twenty years before the completion of Glen Canyon Dam, Art Greene pioneered 65-mile upriver trips from Lees Ferry to Rainbow Bridge. In 1950, the Greene family opened the Cliff Dwellers Lodge, which provided tourists with a motel, café, and gas station. It also served as a base for Greene's tour company, Canyon Tours, Inc. (Photograph by Esther Mallett; courtesy of the William and Eva Jones Collection, Powell Museum Archives.)

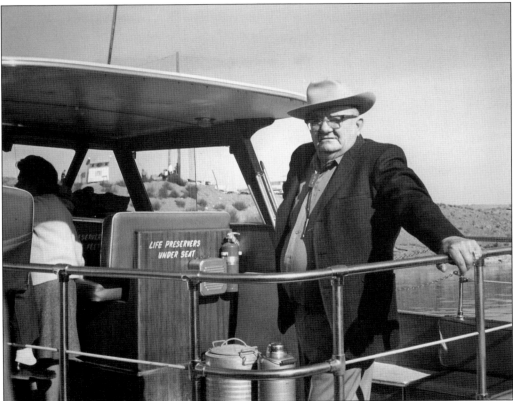

In 1959, the National Park Service officially awarded Art Greene the concession for operating all recreational facilities on the southern end of Lake Powell. Pictured here in the 1960s, his work and creative vision helped develop and expand tourism on Lake Powell. (Photograph by Harvey Gardner; courtesy of the Powell Museum Archives.)

The Wahweap Marina Store was operated by Glen Canyon National Recreation Area concessioner Canyon Tours, Inc. Prior to the completion of launch ramps at Wahweap Marina, boaters had to drive 23 miles along Kane Creek Road to put in at Padre Bay. This photograph was taken in the late 1960s. (Courtesy of the Glen Canyon National Recreation Area Archives.)

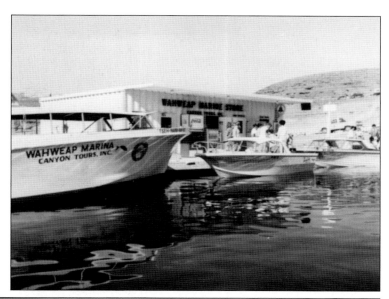

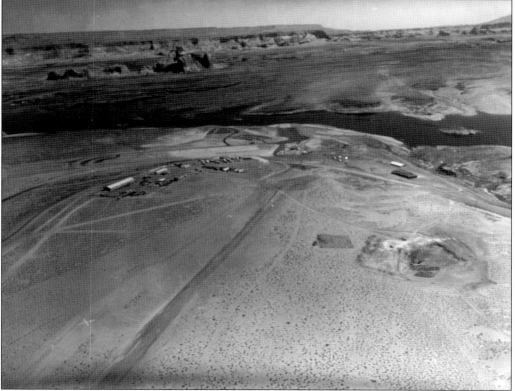

Lake Powell Motel and Restaurant and Wahweap Lodge and Marina became popular destinations for people from around the world. Del Webb purchased Wahweap Marina from the Art Greene family in 1976. He later purchased Hite, Bullfrog, and Hall's Crossing marinas after being awarded the concession by the National Park Service. (Courtesy of the Glen Canyon National Recreation Area Archives.)

Art Greene's son-in-law Earl Johnson and US Bureau of Reclamation engineer Bob Kolterman relax at the Aztec Creek campsite, the departure point for the hike to Rainbow Bridge, on June 19, 1960. Thousands of people visited the monument in the 1960s, and, by the 1980s, hundreds of thousands of annual visitors were recorded at Rainbow Bridge. (Photograph by A.E. Turner, US Bureau of Reclamation; courtesy of the Powell Museum Archives.)

Before Lake Powell filled, there were limited ways to reach Rainbow Bridge. Visitors accessed the monument either by horseback or foot from Navajo Mountain or by boat and foot from the Colorado River. Art Greene provided trips up the Colorado River from Lees Ferry using modified airboats. A visitor admires Rainbow Bridge in this 1960s photograph. (Photograph by Glen Canyon National Recreation Area, National Park Service; courtesy of the Powell Museum Archives.)

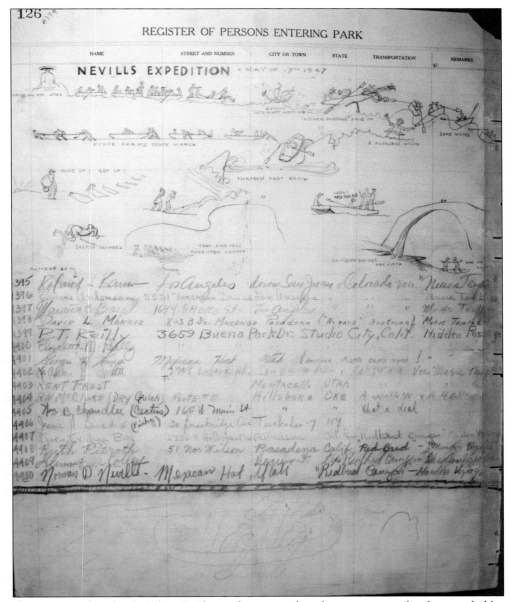

A register was placed at Rainbow Bridge to document the adventurous people who traveled long distances to see the spectacular sandstone marvel. Notables, such as John Wetherill, Bert Loper, and Zane Grey, signed the book on trips to the bridge (as did many passengers from Canyon Tours, Inc., and Nevills Expeditions). With the completion of Glen Canyon Dam in 1963 and the filling of Lake Powell, there was growing concern that the encroaching waters would destroy the religious integrity of the sacred monument. The Navajo Legal Aid Society filed suit to stop waters from Lake Powell from entering Bridge Canyon and to restrict access to Rainbow Bridge. It was ruled that the national monument was a public place and that all members of the public had equal right to its access and use. The National Park Service still works closely in cooperation with tribal representatives to ensure a balance of access and religious freedom and to encourage respect for cultural landscapes. (Courtesy of the Glen Canyon National Recreation Area Archives.)

The rapidly rising waters of the Colorado River behind Glen Canyon Dam flooded numerous canyons, thereby creating Lake Powell (a 186-mile-long reservoir with almost 2,000 miles of shoreline). As the waters rose, driftwood littered the shores as trees and other vegetation were covered. The National Park Service had an immediate presence in the Glen Canyon area. It worked to establish access and other services well before Glen Canyon National Recreation Area was officially established in October 1972. Glen Canyon National Recreation Area staff is in charge of preserving and providing access to over 1.2 million acres of water-based and backcountry lands (from Lees Ferry in the south to the Orange Cliffs in the north). (Courtesy of the Powell Museum Archives.)

As the lake filled, there was growing interest in the Page–Lake Powell area. On March 25, 1966, Glen Canyon National Recreation Area superintendent Gustav W. Muehlenhaupt (left) gave a tour of Lake Powell facilities to Elvind T. Scoyen (former associate director of the National Park Service) and Horace M. Albright (former director of the National Park Service). (Courtesy of the Glen Canyon National Recreation Area Archives.)

Pictured in 1963, the Glen Canyon National Recreation Area employees are, from left to right, as follows: (first row) Clarence Smith, Vaughn Gray, Don Riggs, Byron Baughman, and Dick Snow; (second row) Wayne Alcorn, Ed Mazzer, Donna Bloxton, Seymour Parkes, John Mullady, Jim Eden, Don Jackson, Bennie Garcia, Elmer Solomon, Keith Wilkins, Carl Krigbaum, Wayne Corbit, and Cloyd Chalk; (third row) Wilmer Salmon, Lyle Jamison, Chris Cameron, Gary Bierhaus, Adrian Kitchen, Marion Clark, Neaf Swapp, Tom Brewster, and Marion Thurston. (Photograph by Wayne B. Alcorn; courtesy of the Glen Canyon National Recreation Area Archives.)

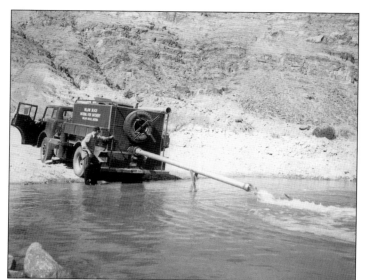

The US Fish and Wildlife Service, Utah Department of Fish and Game, and the Arizona Game and Fish Department planted various species of fish by truck and airplane into Lake Powell, providing world-class fishing opportunities for anglers. In 1974, Sam LaManna caught Lake Powell's record largemouth bass (10 pounds 2 ounces) in Warm Creek Bay. (Photograph by A.E. Turner, US Bureau of Reclamation; courtesy of the Powell Museum Archives.)

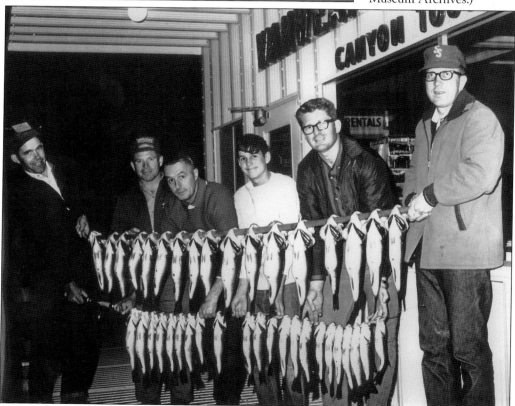

Largemouth bass, smallmouth bass, striped bass, rainbow trout, crappie, and catfish were a few of the species of fish inhabiting the waters of Lake Powell. Standing outside of the Wahweap Marina store and holding a string of bass taken from Lake Powell are, from left to right, Val Wave, Brant Lee, Al Roueche, Donald Roueche, Darrel Adir, and Carl Tuft. (Photograph by Harvey Gardner; courtesy of the Powell Museum Archives.)

Sightseeing, boating, fishing, and swimming are some of the top recreational activities at Lake Powell. By the late 1980s, more than 3.5 million visitors were recreating in Glen Canyon National Recreation Area annually. A visitor enjoys Lake Powell's magnificent view on June 19, 1966. (Photograph by Fred S. Finch, US Bureau of Reclamation, Howell R. Gnau Collection; courtesy of the Powell Museum Archives.)

In 1967, Stan Jones published the first map of Lake Powell, which was annually updated. The fluctuating lake levels provide endless opportunities to explore Lake Powell by boat and foot. Boats launch from one of four marinas located on the lake. (Photograph by the Glen Canyon National Recreation Area, National Park Service; courtesy of the Powell Museum Archives.)

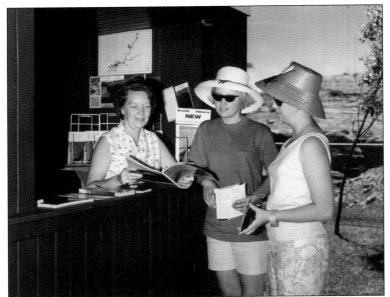

A small visitor information booth was set up along Highway 89 near Glen Canyon Bridge before the permanent visitor center was built. Alice Jones hands out information about Lake Powell and the surrounding area to visitors on May 29, 1966. (Photograph by Fred S. Finch, US Bureau of Reclamation; courtesy of the Powell Museum Archives.)

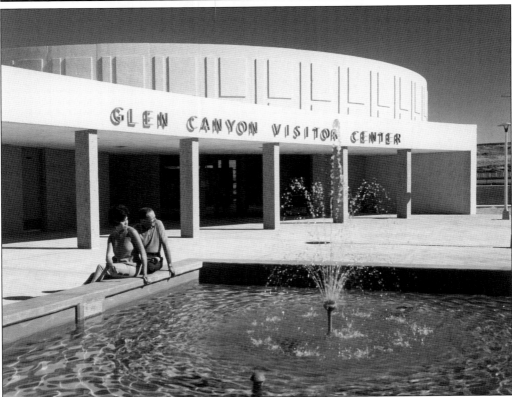

The Glen Canyon Visitor Center, which later became Carl Hayden Visitor Center, was completed in 1963. Commissioner of the US Bureau of Reclamation Floyd E. Dominy acted as master of ceremonies for the dedication of the Carl Hayden Visitor Center in 1968. (Photograph by the US Bureau of Reclamation; courtesy of the Powell Museum Archives.)

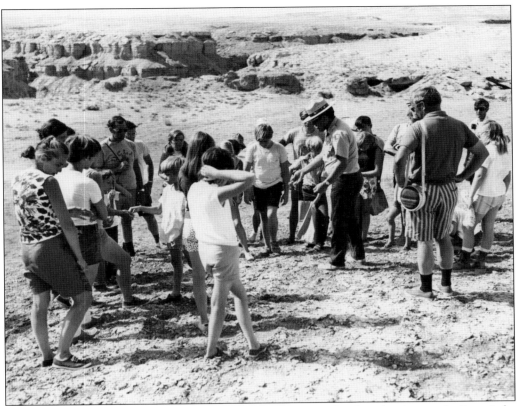

National Park Service rangers provided interpretive programs to locals and visitors to the Page–Lake Powell area, thereby fostering an appreciation for the immense variety of resources available in Glen Canyon National Recreation Area. Ranger Jack Foster leads participants in the Fossil Safari interpretive program on August 1, 1971. (Photograph by N.W. Salibury; courtesy of the Glen Canyon National Recreation Area Archives.)

Lynne Rocke, participant in Glen Canyon National Recreation Area's summer 1971 Neighborhood Youth Corps Program, is pictured as she gives an interpretive talk to visitors at Carl Hayden Visitor Center. The visitor center was equipped with modern exhibits and interpretive information and was the venue for various outreach programs and demonstrations. (Courtesy of the Glen Canyon National Recreation Area Archives.)

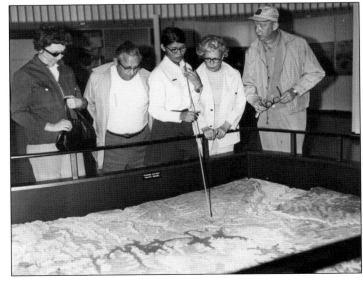

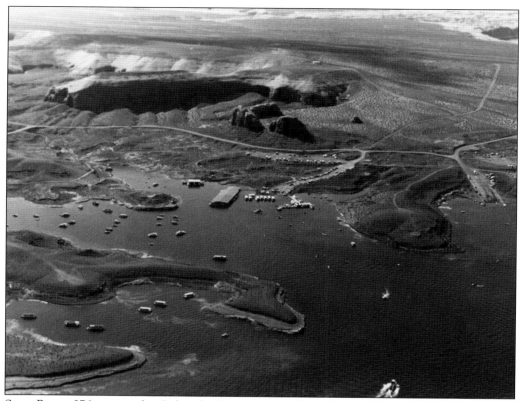

State Route 276 crosses the Colorado River through Glen Canyon National Recreation Area between Halls Crossing and Bullfrog Marina. Halls Crossing Marina (located about 95 miles upstream from Glen Canyon Dam) provides many visitor services, including a National Park Service ranger station. (Courtesy of the Glen Canyon National Recreation Area Archives.)

The original ferry at Halls Crossing was run by Charles Hall, a Mormon pioneer who settled at the mouth of Halls Creek in 1881 and ran a ferry across the Colorado River. After Glen Canyon Dam was built, a ferry service was established and run by concessioner Frank Wright. (Courtesy of the William and Eva Jones Collection, Powell Museum Archives.)

Bullfrog Marina is located approximately 90 miles upstream from Glen Canyon Dam. A ferry service between Bullfrog and Halls Crossing Marina operates on a regular basis to allow pedestrians, cars, trucks, motor homes, and buses passage across Lake Powell. (Photograph by the Glen Canyon National Recreation Area, National Park Service; courtesy of the Powell Museum Archives.)

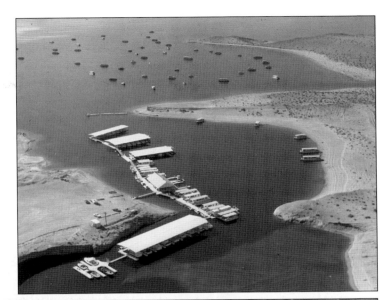

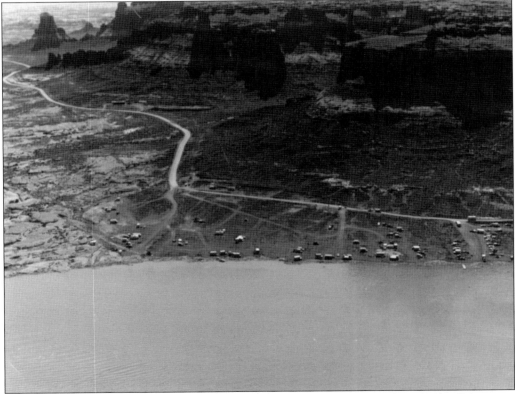

Hite Marina, named for Cass Hite, provides seasonal boat access depending on the fluctuating water levels of Lake Powell. Utah State Route 95 crosses the Colorado River over the Hite Crossing Bridge, connecting the area to the north side of the lake. Gaylord and Joan Nevills-Staveley operated the marina located at North Wash on Lake Powell in the 1960s. (Courtesy of Glen Canyon National Recreation Area Archives.)

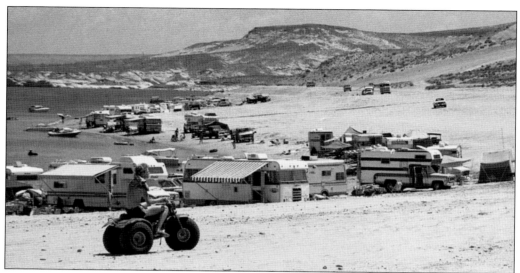

Pictured here in August 1980, Lone Rock Beach continues to be a popular recreation area for swimming, camping, and four-wheeling. On holiday weekends, such as Labor Day and Memorial Day, visitors can expect a crowded scene with thousands of people enjoying the sandy section of Lake Powell shoreline. (Photograph by Julia P. Betz, *Lake Powell Chronicle*; courtesy of the Powell Museum Archives.)

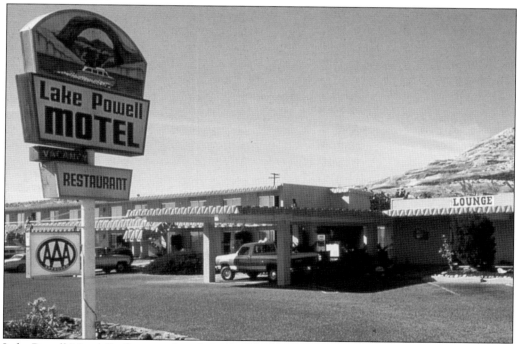

Lake Powell Motel (built, owned, and operated by Art Greene) initially included 24 motel units, a curio shop, restaurant, and service station. Constructed in 1962, the motel was a popular place for locals to eat and visitors to stay. Although no longer in operation, it was located along Highway 89 about six miles north of Page. (Photograph by Steven F. Ward; courtesy of the Powell Museum Archives.)

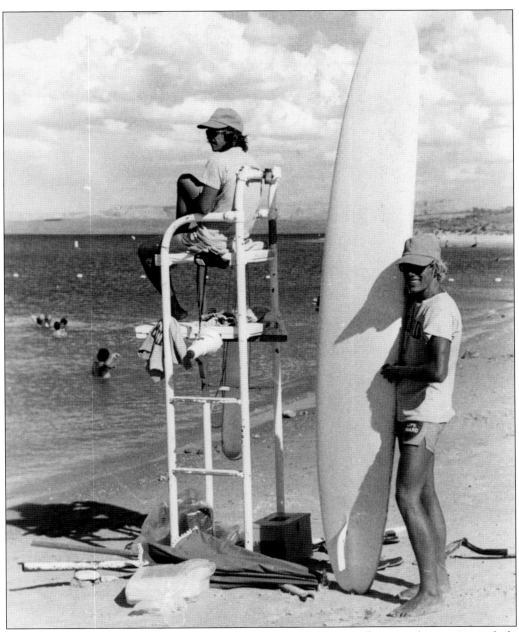

Beginning in the 1960s, lifeguards were stationed at Wahweap Beach, a popular swimming hole on the shores of Lake Powell, in the summer months. In order to allow visitors a place to swim, a designated area was marked off by buoys to indicate a no-boating zone in the Wahweap channel. Brian (seated) and John Gates (standing) are pictured at Wahweap Beach during the summer of 1978. There no longer are lifeguards at Lake Powell. (Courtesy of the Glen Canyon National Recreation Area Archives.)

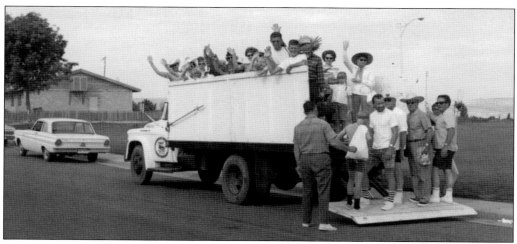

Sanderson Brothers Expeditions (a local Colorado River running company) donated time, equipment, and staff to raise funds for the establishment of the Powell Museum. Float trips from the bottom of Glen Canyon Dam to Lees Ferry were organized with all proceeds going to the museum. Passengers were loaded into the back of trucks and transported through the access tunnel to the base of the dam. (Photograph by Stan Jones; courtesy of the Powell Museum Archives.)

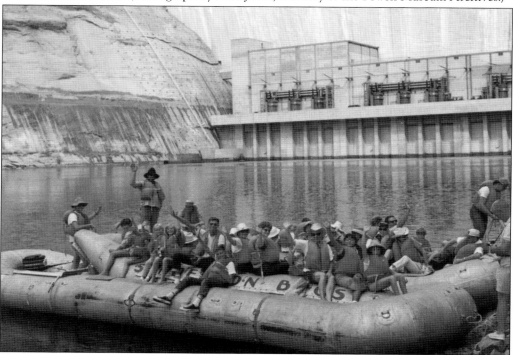

Downstream Colorado River running companies headquartered in Page, Arizona, included Sanderson Brothers Expeditions, the Fort Lee Company, Diamond River Adventures, and Wilderness River Adventures. The first float trips from the dam to Lees Ferry were special fundraising trips provided by Sanderson Brothers Expeditions. Regularly operated float trips were later run by the Fort Lee Company, until Wilderness River Adventures took over in 1983. (Photograph by Stan Jones; courtesy of the Powell Museum Archives.)

Six

FILMMAKING

Since John Ford's *Stagecoach* was filmed in Monument Valley in the 1920s, the unique terrain of the High Desert Southwest has attracted filmmakers from around the world. The red rocks, lonely, barren deserts, and lakeshores of the Page and Lake Powell area have been depicted as the Holy Land, alien planets, midwestern riverboat causeways, and post-apocalypse Earth. The Colorado River was featured in the *Ten Who Dared*, a Disney film that told the story of John Wesley Powell and his brave companions' 1869 river adventures.

With numerous movies, documentaries, and television shows filmed in the Glen Canyon region, famous actors and actresses were commonly seen in Page and on Lake Powell. Some of the Hollywood stars included Gregory Peck, Omar Sharif, and Julie Newmar (*MacKenna's Gold*, 1967); James Stewart, Dean Martin, and Raquel Welch (*Bandolero!*, 1969); and Clint Eastwood (*The Outlaw Josie Wales*, 1975). In 1963, Charlton Heston played the key role of John the Baptist in *The Greatest Story Ever Told*, baptizing Max Von Sydow, who played Jesus, in the waters of Lake Powell. Heston returned to Lake Powell (and to Earth) as astronaut George Taylor in the original *Planet of the Apes* in 1968.

Television series were often filmed in and around Page, including *Lassie* and *Route 66* (1960s), *The Lucy Show* (1970s), *The Greatest Heroes of the Bible* mini-series (1978), *The Fall Guy* (1980s), and *St. Elsewhere* (1986). News and documentary programs broadcast from the area, including *60 Minutes*, *48 Hours*, and *National Geographic*.

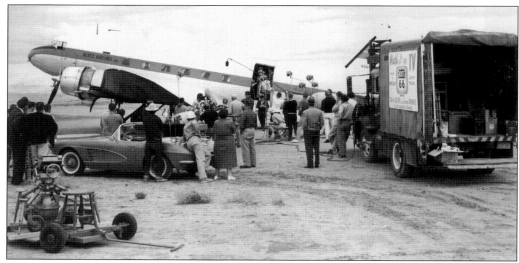

Seen here on October 18, 1960, two segments of the popular action series *Route 66* were filmed in and around Page, Arizona. Crew for the television show shot scenes at the Page Airport near Glen Canyon Dam, the Kane Creek area, and other locations. (Photograph by A.E. Turner, US Bureau of Reclamation; courtesy of the Powell Museum Archives.)

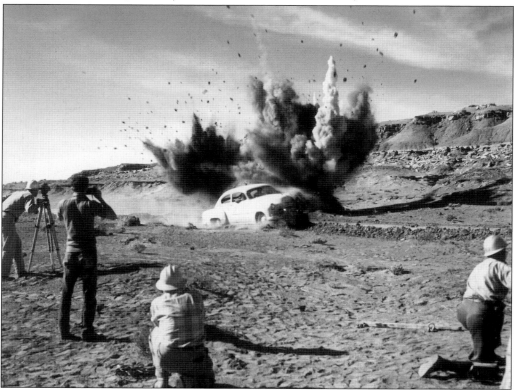

A car speeds down the Kane Creek Road while explosive blasts shoot skyward during filming of *Route 66* on October 22, 1960. Elliot Silverstein directed the series. (Photograph by A.E. Turner, US Bureau of Reclamation; courtesy of the Powell Museum Archives.)

Martin Milner, costar of the television show *Route 66*, poses for a photograph during filming near the Glen Canyon Dam construction site on October 23, 1960. Other cast members included George Maharis, Charles McGraw, Bethel Leslie, Zohra Lampert, Richard Shannon, Vana Leslie, Donna Douglas, and William Benedict. (Photograph by A.E. Turner, US Bureau of Reclamation; courtesy of the Powell Museum Archives.)

In this October 23, 1960, photograph, the crew for *Route 66* shot scenes below the Glen Canyon Dam construction site along the Colorado River. Lead characters Tod Stiles (Martin Milner) and Buz Murdock (George Maharis) played laborers on the dam project in Page, Arizona. (Photograph by A.E. Turner, US Bureau of Reclamation; courtesy of the Powell Museum Archives.)

Many local people worked as extras in the filming of *The Greatest Story Ever Told*. George Stevens Productions built a temporary set of Jerusalem at the base of Castle Rock. He also constructed the home of Lazarus—complete with vineyards and trees—on the back side of Castle Rock. This photograph of the set was taken on February 27, 1963. (Photograph by Wilbur L. Rusho, US Bureau of Reclamation; courtesy of the Powell Museum Archives.)

George Stevens Production Company brought a crew of 200 people and spent approximately two million dollars during a seven-month period filming *The Greatest Story Ever Told* near Page, Arizona. Shown in this March 1963 photograph, camels and other animals were also brought to the area to be used in the filming of the movie, which was released by United Artists. (Courtesy of the Jesse Allen Collection, Powell Museum Archives.)

The film *The Greatest Story Ever Told* recounted the life of Jesus Christ and was based on the book by Fulton Oursler. It was directed by George Stevens, David Lean, and Jean Negulesco. The cast included Max von Sydow (who played Jesus), Michael Anderson Jr., Carroll Baker, Ina Balin, Victor Buono, Richard Conte, Joanna Dunham, Jose Ferrer, Van Heflin, Charlton Heston, Martin Landau, Angela Lansbury, Pat Boone, Janet Margolin, David McCallum, Roddy McDowall, and Dorothy McGuire. This photograph was taken on January 14, 1963. (Photograph by Wilbur L. Rusho, US Bureau of Reclamation; courtesy of the Powell Museum Archives.)

Filming of the *Planet of the Apes*, directed by Franklin J. Schaffner, took place during the summer of 1967. A spaceship used in the movie is pictured at the Wahweap ramp facilities. The cast included Charlton Heston, Roddy McDowall, Kim Hunter, Maurice Evans, James Whitmore, James Daly, Linda Harrison, Robert Gunner, Lou Wagner, and Woodrow Parfrey. (Photograph by Dwight Hamilton; courtesy of Glen Canyon National Recreation Area Archives.)

MacKenna's Gold film crew and cast are pictured here in 1968, including (front row) J. Lee Thompson (director), unknown, Omar Sharif, Stewart Udall (secretary of the interior), and Camilla Sparv. The action western starred Gregory Peck (MacKenna) and Omar Sharif (Colorado), with Telly Savalas and Camilla Sparv. (Courtesy of the Glen Canyon National Recreation Area Archives.)

Filming of *Bandolaro!* took place in several locations near Page, Arizona, and Kanab, Utah, as well as along Warm Creek Road at the base of Smoky Mountain (near present day Big Water, Utah). Andrew V. McLaglen directed the film. (Courtesy of the Stan Jones Collection, Powell Museum Archives.)

Some scenes for *Bandolaro!* were filmed at night near Big Water, Utah, in Crazy Horse Canyon. The cast included James Stewart, Dean Martin, Raquel Welch, George Kennedy, Andrew Prine, Will Geer, Clint Ritchie, Denver Pyle, Tom Heaton, Rudy Diaz, Sean McClory, Harry Carey Jr., Don "Red" Barry, Guy Raymond, Perry Lopez, Jock Mahoney, Dub Taylor, Big John Hamilton, Robert Alder, John Mitchum, Patrick Cranshaw, and Roy Barcroft. (Courtesy of the Stan Jones Collection, Powell Museum Archives.)

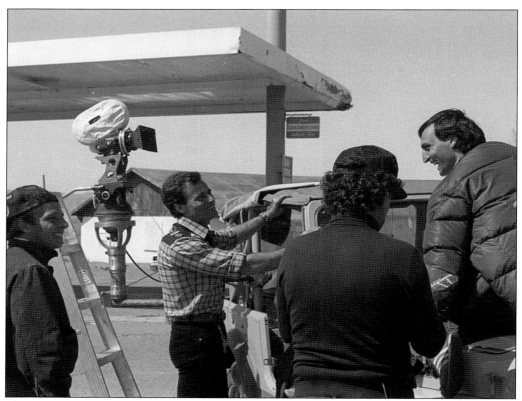

The European International Film Company from Rome, Italy, was given permission to destroy an old gas station and trading post at Bitter Springs during the filming of *Thunder Warrior*, which starred Bo Swenson, Mark Gregory, Raimund Harmstorf, Valeria Cavelli Ross, and Antonio Sabato (pictured standing next to the Jeep in April 1983). Scenes for the film, which was directed by Fabrizio deAngelis, were also shot in Page. (Photograph by Julia P. Betz, *Lake Powell Chronicle*; courtesy of the Powell Museum Archives.)

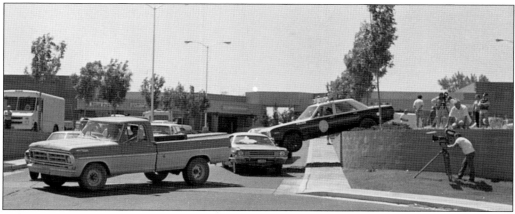

Italian movie company Fulvia Films from Rome, Italy, filmed *The Manhunt* at several locations in Page, Arizona. The action-packed western was directed by Giancarlo Granatelli. John Wayne's son Ethan Wayne starred in the film. This June 1984 photograph captures some of the action. (Photograph by Jim Largo, *Lake Powell Chronicle*; courtesy of the Powell Museum Archives.)

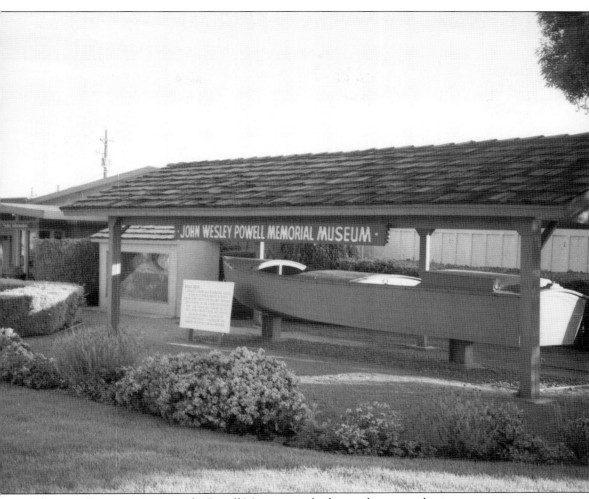

Like many Page organizations, the Powell Museum was built on volunteer enthusiasm, commitment, and labor. In 1968, Page Chamber of Commerce president William Warner suggested to chamber members that they seek ways to establish a museum and visitor center in downtown Page. Warner also urged members to create events that would focus attention on the town as a part of the upcoming John Wesley Powell Centennial in 1969. As a result of that meeting, land and a building were donated, and extensive renovations (led by museum committee member Stan Jones) began in early 1969. Walt Disney Studios donated the "Emma Dean" boat used in the filming of *Ten Who Dared*. Glen Canyon Trading Post owners Roger and Marie Golliard donated their extensive collection of Native American objects and their world-renowned collection of fluorescent rocks. On August 1, 1969, the Powell Museum opened its doors with a grand celebration. Local volunteers continued to support and expand the organization. Museum committee member June Sanderson and Sanderson Brothers Expeditions organized guided float trips from the bottom of Glen Canyon Dam to Lees Ferry and donated the trip proceeds to the museum for several seasons. Today, the museum continues to collect, preserve, and interpret the history of John Wesley Powell, the city of Page, and the Colorado Plateau. The Powell Museum welcomes visitors from around the world. (Courtesy of the Powell Museum Archives.)

DISCOVER THOUSANDS OF LOCAL HISTORY BOOKS FEATURING MILLIONS OF VINTAGE IMAGES

Arcadia Publishing, the leading local history publisher in the United States, is committed to making history accessible and meaningful through publishing books that celebrate and preserve the heritage of America's people and places.

Find more books like this at
www.arcadiapublishing.com

Search for your hometown history, your old stomping grounds, and even your favorite sports team.